CHAGALL

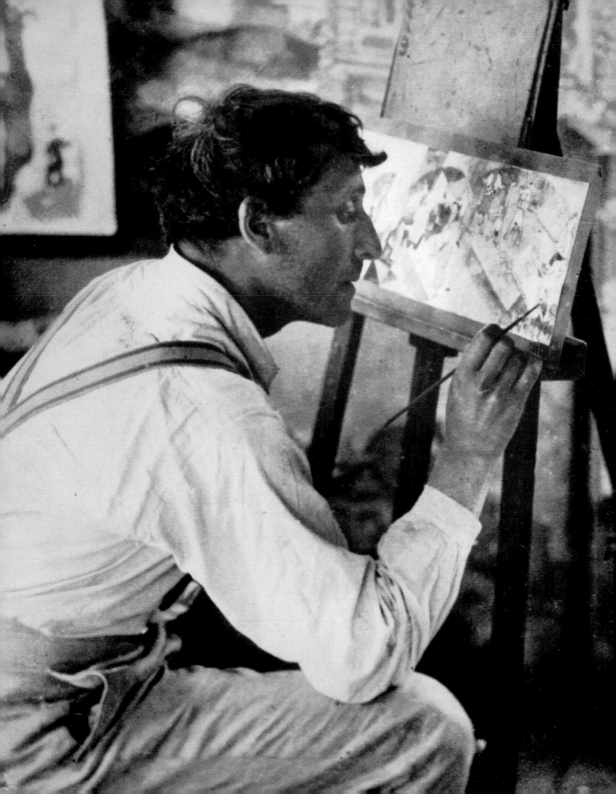

MASTERS OF ART

CHAGALL

Ines Schlenker

PRESTEL

Munich · London · New York

Front Cover: Marc Chagall, The Dance, 1950
© Adagp Images, Paris / SCALA, Florence

© Prestel Verlag, Munich · London · New York, 2022,
A member of Penguin Random House Verlagsgruppe GmbH
Neumarkter Straße 28 · 81673 Munich

Copyright for the works of Marc Chagall: ©VG Bild-Kunst, Bonn 2022

In respect to links in the book, Penguin Random House Verlagsgruppe
expressly notes that no illegal content was discernible on the linked
sites at the time the links were created. The Publisher has no influence
at all over the current and future design, content or authorship of the
linked sites. For this reason Penguin Random House Verlagsgruppe
expressly disassociates itself from all content on linked sites that has
been altered since the link was created and assumes no liability for
such content.

Editorial direction: Constanze Holler
Copyediting: Vanessa Magson-Mann, So to Speak
Production management: Andrea Cobré
Design: Florian Frohnholzer, Sofarobotnik
Typesetting: ew print & medien service gmbh
Separations: Reproline mediateam
Printing and binding: Litotipografia Alcione, Lavis
Typeface: Cera Pro
Paper: 150g Profisilk

MIX
Paper from
responsible sources
FSC® C021956
FSC www.fsc.org

Penguin Random House Verlagsgruppe FSC® N001967

Printed in Italy

ISBN 978-3-7913-8660-7

www.prestel.com

CONTENTS

6 Introduction

8 Life

38 Works

110 Further Reading

INTRODUCTION

Marc Chagall is one of the most important and best-loved artists of the twentieth century. During a prolific career that spanned eight decades, he produced a vast body of work that includes some of the most innovative and iconic images in the history of art. He exerted enormous influence on both his contemporaries and subsequent generations of artists. Hailed as a pioneer of European Modernism, in particular as a precursor of Expressionism and Surrealism, he became a leader of progressive art in post-Revolutionary Russia and, after the deaths of Henri Matisse and Pablo Picasso, the only surviving great hero of the European avant garde of the early twentieth century.

Looking back in later life, Chagall summed up his ambitious artistic intentions: "I had never wanted to paint like any other painter: I always dreamed of some new kind of art that would be different." And indeed, his art, instantly recognisable and indelibly memorable, could never be mistaken for anyone else's. Inspired by his multicultural background and developed in the course of a restless life, it fuses Eastern and Western traditions in a unique way. During his stay in Paris before the First World War, he had encountered the latest avant-garde movements and forged his distinctive, highly personal pictorial language. Absorbing and adapting elements from Fauvism, Cubism and Orphism, it also took inspiration from Jewish art, Christian icons and Russian folk art, later further incorporating Suprematist influences. Exotic and deliberately primitive, it stands out for its use of intense, often non-naturalistic colour.

Chagall's subject matter is also deeply personal and can be divided into three main themes. The first conjures up his Jewish-Russian home—for most of his life relying solely on memory—and made his name virtually synonymous with his birthplace. The second immortalises the trauma caused by the destruction of the European Jewry during the Holocaust. The third celebrates life, capturing his deep empathy for all living creatures, his love for his wife Bella above all, and his inherent *joie de vivre*. His works, variously described as dreams, myths, visions, fantasies or fairy tales in their attempt to go beyond reality, are elaborate compositions full of surreal humour and hidden meanings. They rely on a complex and idiosyncratic set of imaginative motifs which includes flying figures and violin-playing animals, reassembled in endless variations.

Chagall, though best known for his paintings, worked in many different media, ranging from drawing, printmaking, book illustration, stained glass windows, murals, ceramics and sculpture to set and costume design. Much of his artistic output was created under difficult circumstances, as an outsider fighting for survival and professional recognition. It was against the odds that he set out to become an artist at all, overcoming the restrictions his upbringing in the enclosed Hasidic Jewish community of the provincial Belorussian town of Vitebsk, then part of Imperial Russia, imposed. During his early career his art was often misunderstood and mocked, both in Russia and Paris. His refusal to give up his figurative style and follow the officially prescribed abstraction in post-war Russia led to ostracism and lasting exile from his home country. The rise of the National Socialists presented him with an even greater threat. As a Jew who painted Jewish subject matter in a modern style, his life was in imminent danger after the German invasion of France, forcing him into exile yet again.

For Chagall, life and art were inextricably intertwined. His struggle with poverty, loneliness, war, revolution, exile, persecution and loss are as directly and equally mirrored in his works as are joy, happiness and relief at survival. He transforms his moods and experiences, which reflect both the troubled history of the twentieth century and universal human sentiments, into symbolic images which, in their simplicity, immediacy and message of peace, hope and love, speak to everyone. Timeless and topical, Chagall's art is set to enjoy enduring popular appeal.

This book presents an overview of Chagall's eventful life and oeuvre—outstanding in its variety and originality. The biography is followed by a selection of thirty-five artworks that trace and exemplify his artistic development. They document his difficult journey from humble beginnings in Vitebsk, where he had not even encountered a drawing while growing up, to a wealthy, world-famous, cosmopolitan artist.

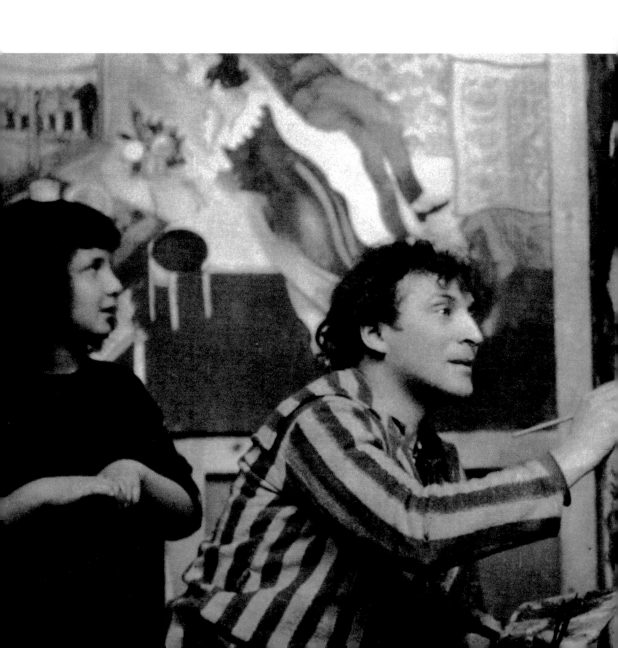

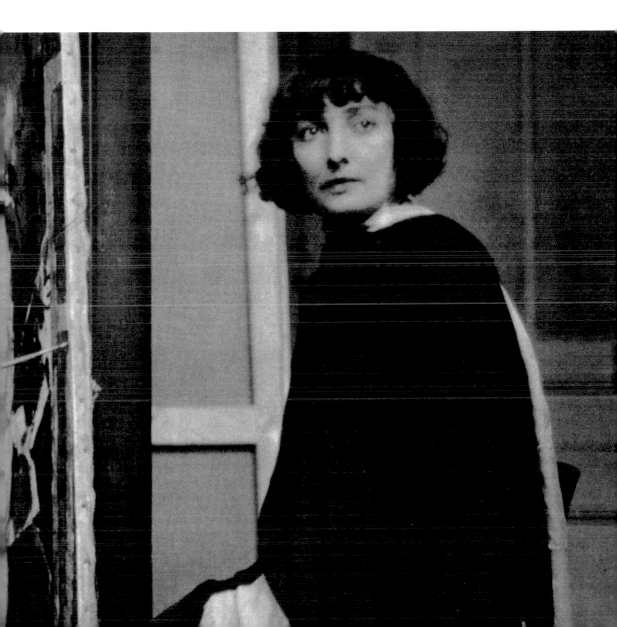

Marc Chagall was born as Moyshe Shagal on 7 July 1887 in the Belorussian town of Vitebsk. The heart of the lively commercial and military centre on the river Dvina was dominated by splendid Baroque palaces and onion-domed churches (opposite). In contrast, the town's outskirts consisted of unpaved, rickety roads, lined with modest wooden houses where animals were kept in the backyard. Most of Vitebsk's Jews lived here in humble circumstances and tightly-knit communities. Chagall's pious father worked as a manual labourer in a herring warehouse and his mother ran a grocery shop. Their nine children were brought up in the Orthodox Hasidic Jewish milieu which, upholding a distinct identity and strictly observant, was marked by deep compassion for the animal world and a belief in the supernatural. Unusually, Chagall, after completing a traditional Jewish elementary school, continued his education at a Russian secondary school. Adjusting to this alien environment was difficult for him. He faced antisemitism and was forced to learn a new language and, as a consequence, developed a stammer. Yet the school opened his eyes to mainstream Russian and Christian culture, presenting him with the first step on his way out of an enclosed, restricted upbringing. He also learnt to adapt to new circumstances, a skill on which he would repeatedly rely later in life.

A gifted violinist with a good singing voice, the young Chagall was torn between becoming a musician, dancer or poet. He realised that he had a talent for drawing when the copies he made of illustrations found in magazines were praised

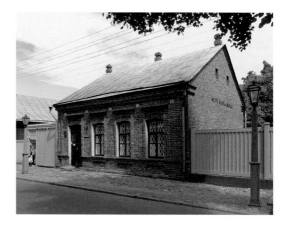

Childhood home, now Museum of Marc Chagall in Vitebsk

by a schoolmate. Art had so far been lacking in his life. Growing up in a religion that prohibited the creation of figurative art, he had no idea what an artist was. Yet, defying Jewish customs and his family's objections, Chagall set out to turn his passion into a profession. Yehuda Pen, a painter well-known for his depictions of Jewish life in a traditional style, recognised some ability in the drawings he was shown and accepted Chagall at his School of Drawing and Painting in Vitebsk. For a time this was the only art school in the Pale of Settlement, the western part of the Russian Empire to which the Jewish population had been confined since the late eighteenth century. The school prided itself on enabling Jews to become artists and provided a solid training in

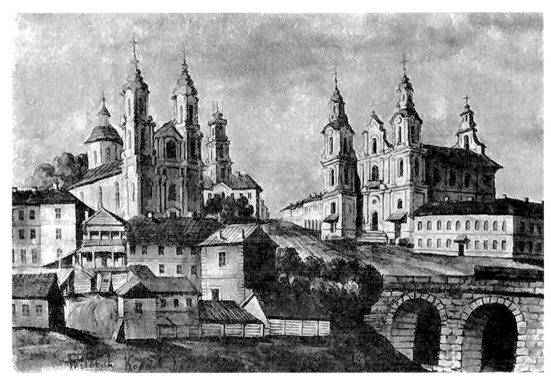

Napoleon Orda, *Vitebsk*, 19th century

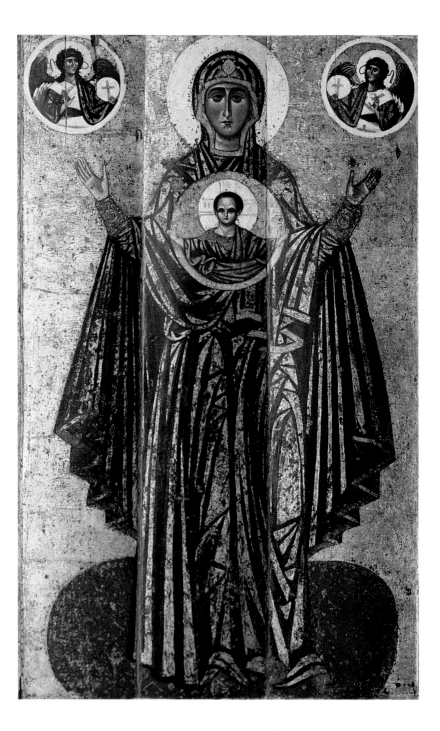

the basic artistic techniques. Chagall discarded his teacher's realism, preferring to employ a more primitive, deliberately naïve style, and learnt to create pictures that tell a story, following a tradition in Russian art. Most importantly, Pen taught him that Jewish subject matter was worthy of depiction and that he could be an artist despite being Jewish. Art was his route to freedom, and by 1907 Chagall was ready for "a new life, in a new town". He moved to St. Petersburg, leaving behind the confines of his childhood home which he would recreate in his paintings from now on.

A poor, shy newcomer from the provinces, he initially felt overwhelmed and threatened by Russia's capital. It did not help that, as a Jew who wanted to live outside the Pale of Settlement, he needed a special permit to enter St. Petersburg. Since he failed to procure the correct papers, he repeatedly found himself in trouble with the Tsarist authorities over the coming years. Still, he managed to find work as a retoucher in a photographic studio and became a student at the school of the Imperial Society for the Protection of the Arts. Unimpressed by his instructors, however, Chagall sought inspiration in the city's museums where he studied Christian icons (page 12), explored the Hermitage's collection of Old Masters and, through the bravely coloured, bold compositions of Wassily Kandinsky, for the first time encountered examples of modern Western art that were still rare in Russia. Although he won a scholarship, he felt that his work was not appreciated at the school and, after being insulted by a teacher, returned to Vitebsk in summer 1908. His

homecoming was marked by two major events: the creation of *The Dead Man* (pages 40/1), the first work unmistakably by Chagall, and the encounter with Bella Rosenfeld, his future wife. In contrast to his own modest origins, Bella, whose parents owned three jewellery shops, belonged to the wealthy middle class. Their upbringing, however, was very similar. Raised in the Hasidic faith, she grew up with the same customs and beliefs as Chagall, although her family was more secular. In the years to come, especially in exile, Bella would provide the vital link to his Jewish-Russian past. Well-educated, stylish and self assured, she became Chagall's most loyal and ardent supporter, as well as his muse. Yet for the moment, her parents were against her liaison with a penniless art student, and so Chagall returned to St. Petersburg to prove himself.

Towards the end of 1909 he joined the Zvantseva School, where Léon Bakst became one of his teachers. A famous Jewish painter who had just created much-acclaimed designs for the Ballets Russes in Paris, Bakst was intent on familiarising Russian audiences with modern Western art. Contrary to academic traditions, he encouraged his students to explore fresh means of expression and develop their own style, opening their eyes to the possibilities of using bright colour and strong contrasts as crucial parts of the composition. Through Bakst, Chagall discovered the liberating inspiration of works by French painters such as Cézanne, Manet, Monet, Matisse and Gauguin and later enthused: "Without even knowing there was such a place as Paris, I found a miniature Europe in

Bakst's school." While studying at the Zvantseva School, Chagall also learnt to exploit Russian folk art, with its exotic elements, for his creations (page 15).

Chagall's anti-naturalistic, avant-garde work was severely mocked by a critic when, in spring 1910, it was presented to the public for the first time in a student exhibition of the Zvantseva School. Bakst had recently returned to Paris, and Chagall, frustrated with the restrictions placed on his art by the remaining teachers at the school and convinced that his future was in Europe, decided to follow his example. Maxim Vinaver, a Russian-Jewish lawyer who had recently purchased *The Dead Man*, sponsored the trip and gave him a small stipend. In May 1911, Chagall arrived in Paris with all his paintings, determined to grasp the opportunities the capital of modern art could offer. He would only stay for three years, but these would prove to be formative and turn him into a modern master.

At first, alone and unable to speak French, Chagall struggled in the alien metropolis. He took up art classes at the Académie La Palette and the Académie de la Grande Chaumière but started to look elsewhere for inspiration when the teaching proved to be dull. At the Louvre, he studied the treasures of past centuries, and at the salons and commercial art galleries, he learnt what was currently fashionable. He encountered the latest, radical avant-garde styles and soon realised their exciting possibilities. Within months, he shook off the religious and artistic constraints of his early life and revelled in the new-found freedom. He

Marc Chagall, 1926

experimented with Fauvism's novel way of treating colour and Cubism's shocking fragmentation of form, creating new versions of paintings he had brought with him from Russia. The fundamental new direction his art was taking is exemplified

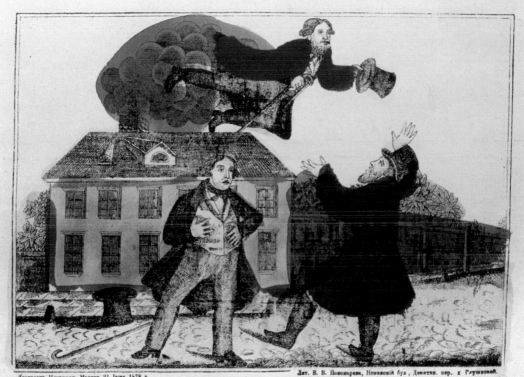

A Man Flying Over a Chimney, Illustration from a Russian book from the 19th century

The Birth, 1910

The Birth, 1911

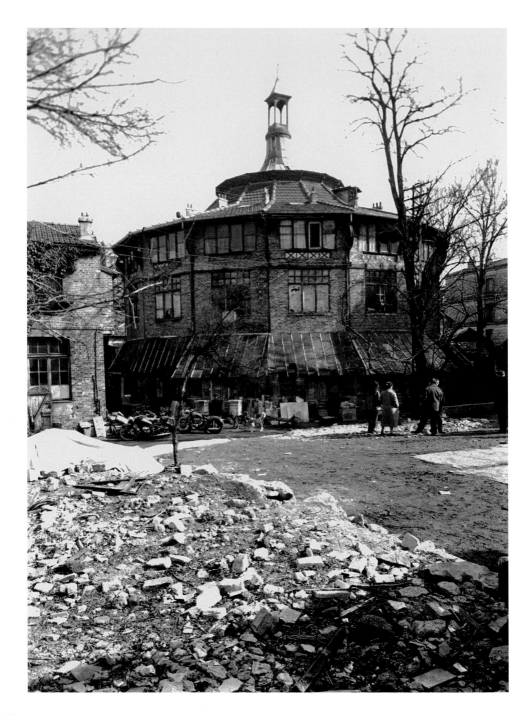

by two versions of *The Birth*, created in 1910 and 1911 (pages 16–19). Both depict a scene familiar to Chagall, who had witnessed the birth of many of his siblings. While the earlier painting is traditional in its use of dark, earthy tones and realistic treatment of space, the later rendering is more complex, bigger, bolder and bursting with bright, non-naturalistic colours, spatial ambiguities and broken perspectives.

In spring 1912, Chagall moved to La Ruche, a vibrant international artists' community in Montparnasse. The accommodation (page 20) was cramped but cheap, and enabled Chagall to paint larger pictures. He kept away from fellow artists whom he suspected of stealing his ideas, seeking the company of writers instead. The Swiss poet Blaise Cendrars introduced him to Robert Delaunay, the founder of Orphism. An offshoot of Cubism, Orphism, with its overlapping, semi-transparent planes of radiant colours, would have a profound impact on Chagall's paintings. Through Cendrars, Chagall also met the poet and art critic Guillaume Apollinaire who would become a staunch supporter of his art. Upon encountering Chagall's paintings for the first time in his studio at La Ruche, Apollinaire elatedly exclaimed: "Surnaturel!" Although the Surrealist movement was not formally formed until 1924, in their disdain of logic, apparent reliance on dreams and peculiar juxtapositions, the works Chagall created in Paris before the First World War are considered to be the first examples of Surrealism.

Backed by a small circle of friends and benefitting from his status as an exotic outsider, a mark of distinction in Paris at the time, Chagall's confidence in his art gradually grew. He then began to arrive at his distinctive style, merging the expressive means of the various avant-garde movements with Russian-Jewish themes. During this period, he created what are arguably the most innovative and original works of his career. The breakthrough came in March 1912 when the radical images he showed at the Salon des Indépendants, among them *To Russia, Asses and Others* (pages 46/7), met with great acclaim. Discarding his Jewish first name and using a different spelling of his family name, he exhibited as "Marc Chagall". From now on he would be a regular participant in the salons.

In spring 1913, mediated by Apollinaire, Chagall made the acquaintance of Herwarth Walden, the owner of the gallery Der Sturm in Berlin and an influential promoter of avant-garde art. Walden invited Chagall to take part in the Erster Deutscher Herbstsalon (First German Autumn Salon), an international overview of modern art. Chagall's paintings, among them *To Russia, Asses and Others* and *Golgotha* (pages 50/1), were enthusiastically received, resulting in further invitations to show his work. The following spring, Chagall travelled to Berlin to attend the opening of his first major solo exhibition at Walden's gallery. It was an enormous success and established him as a major figure of early Modernism. On the eve of the First World War, apart from Kandinsky, Chagall was the most famous Russian artist in the West. He, however, would not become aware of his stellar reputation for years. Shortly after the exhibition opened, he travelled on to Vitebsk to

attend his sister's wedding and finally to marry Bella and return with her to La Ruche. His plans were shattered when war broke out and he found himself trapped in Russia.

Back in his hometown, Chagall discovered the familiar surroundings anew. His compositions became less complex and were carried out in a more realistic manner that softened the fractured forms and garish colours of recent works. He also explored new subject matter that would accompany him for the rest of his life. In the face of rekindled antisemitism and the approaching enemy army, Chagall documented the town's Jewish community, as well as the crowds of Jewish refugees passing through, in numerous works to keep the memory of their appearances and customs alive. While the world around him was in turmoil, Chagall's private life was filled with happiness. It now revolved around Bella who became his wife in 1915. With her, another new theme entered his work that would become one of its dominant features: love (opposite). In addition, in May 1916, Chagall became a father (page 24). His daughter Ida soon provided him with inspiration for paintings. Over the decades to come, Bella, Marc and Ida would constitute a tightly-knit unit that always provided support for each other.

Chagall's artistic reputation in his homeland was also growing rapidly. At the beginning of the war, despite his participation in two exhibitions of avant-garde art in Moscow in 1912 and 1913, he had been mostly unknown in Russia. The Year 1915, a major overview of contemporary art held in Moscow in March 1915, changed this instantly.

Chagall showed twenty-five works to formidable acclaim and was feted as one of the great hopes of Russian art. Not even his conscription in the autumn of the same year could derail his career. He took up a clerical job at the Central Bureau for War Economy in Petrograd, the recently renamed Russian capital, but instead of dedicating much energy to his work, he turned to art to fill his time. He began writing his autobiography, made illustrations for Yiddish books and painted a number of glorious pictures celebrating his relationship with Bella. Sent to avant-garde exhibitions in Petrograd and Moscow, his paintings attracted good reviews. Chagall was now an acknowledged member of the Russian avant garde and a wider public began to take note of his art.

The Russian Revolution in 1917 seemed to further corroborate his newly acquired status. As Chagall would state in his autobiography, the events in the autumn of that year were among the most important moments in his life. Although at heart apolitical, he was sympathetic to the Revolution's aims and nourished the hope that life would improve. The emancipation of Jewish citizens and the abolition of class barriers would surely turn the discrimination and disadvantages he had faced into an advantage that would allow him to now participate fully in society. He left his job in Petrograd and took his family back to Vitebsk. Working in Pen's studio, he created large-scale, euphoric paintings in which he experimented with the new stylistic ideas of Suprematism, integrating some elements of Kazimir Malevich's geometric abstraction in his figurative compositions.

Lovers in Blue, 1914

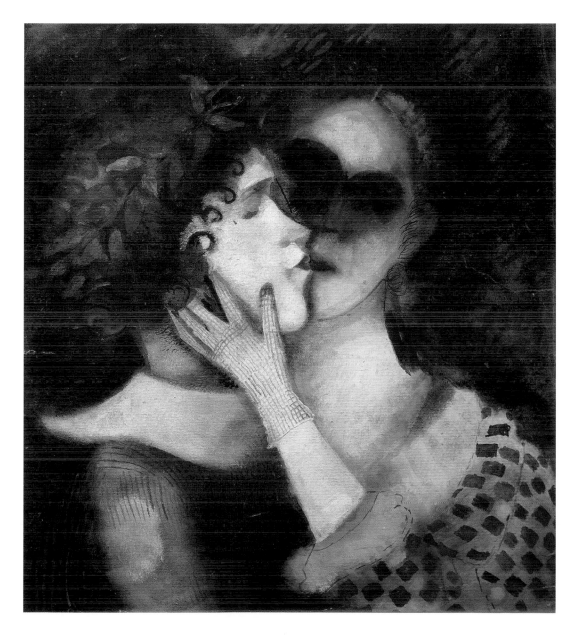

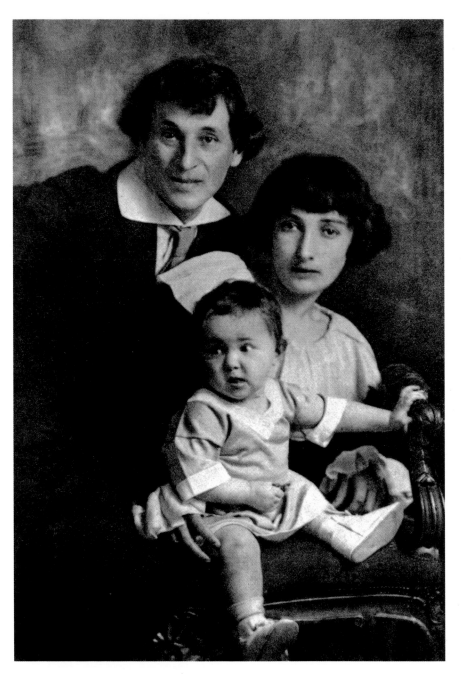

Marc Chagall with wife and daughter, 1917

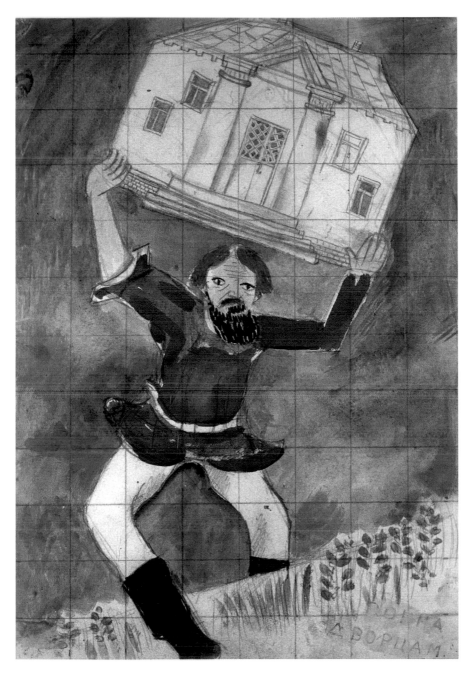

War on Palaces, 1918

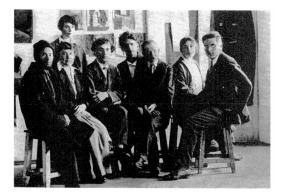

Teachers at the People's Art College in Vitebsk
(Chagall seated, third from left), July 1919

Public recognition was soon to follow. Spring 1918 saw the publication of the first monograph on Chagall in Moscow. Its authors, Abraham Efros and Yakov Tugendhold, extolled Chagall as an eminent representative of contemporary Jewish art, entrusted with determining its direction. In the autumn, Anatoly Lunacharsky, a friend from La Ruche and now the Commissar for People's Enlightenment, offered Chagall the post as Commissar of Arts for Vitebsk. Wary of taking up an official position but longing for formal approval, Chagall accepted and found himself responsible for museums, art schools, exhibitions and cultural events in the region. As a bureaucrat in the Russian state apparatus, he was now placed in a position that allowed him to shape the future of its people.

His first task, the design of street decorations for a parade marking the first anniversary of the Revolution, however, brought home the difficulties involved. Both the public and party officials failed to see the connection between his green cows and flying horses and Marx and Lenin. Yet among the sketches for the celebrations had been one of the few openly propagandistic works in his oeuvre: *War on Palaces* (page 25), a crude attempt to prove his political loyalty.

Undaunted, in January 1919, Chagall founded an art school, the People's Art College in Vitebsk, open to students from poor backgrounds (left). He hired eminent artists from Moscow and Petrograd as teachers, such as El Lissitzky, who had been a fellow student at Pen's, and was himself a much-respected instructor who championed artistic freedom and helped students find their own style. Chagall was now at the height of his fame in post-Revolutionary Russia. His works were shown prominently in the first major overview of Russian avant-garde art at the Winter Palace in Petrograd, attracting glowing reviews. Several paintings, among them *Promenade* (pages 66/7), were acquired by the Russian state. There was, however, trouble brewing. Lacking experience, Chagall cut a poor figure at the helm of the school. Besides struggling with bureaucracy, he was caught up in the ideological battle over what should constitute art for the Soviet people. Compared to the radical abstract Suprematist works by Malevich, Chagall's paintings were found to be too individualistic and unsuitable for the representation of the country's dramatically

changing future. When, in November 1919, Malevich joined the teaching staff and rapidly found many followers, Chagall knew he had lost. In May 1920, he resigned and moved to Moscow with his family.

In disgrace with the authorities, isolated and penniless, Chagall struggled in the country's new capital until, towards the end of the year, he was hired as the stage designer for Alexander Granovsky's Jewish Theatre. The recently established small studio theatre, with its troupe of amateur actors mainly recruited from the shtetl, attempted to keep Jewish culture alive in contemporary Russia. In portraying provincial Jewish life in all its peculiarities on stage, it made the world Chagall depicted in his paintings come alive. Given this perfect fit, he threw himself at the challenge, decorating the auditorium with seven large murals (pages 72/3) and designing the set and costumes for the opening night that featured works by the famous Yiddish playwright Sholem Aleichem. The premiere in January 1921 was a resounding success, and Chagall's designs, admired and later much imitated, set new standards. They were, however, highly impractical and Chagall, who had proved difficult to work with, subsequently could not find further employment at theatres. He briefly taught drawing at the Third International Jewish School-Camp for War Orphans in Malakhovka, a village not far from the capital. Yet, the unremitting struggle for survival and artistic recognition finally convinced Chagall that there were no prospects for him in Russia and that it might even be dangerous for him to stay. He finished writing

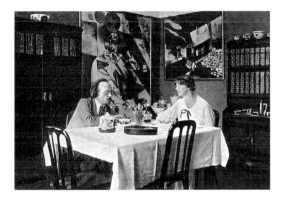

Herwarth and Nell Walden in their Berlin apartment in front of Chagall paintings, 1919

his autobiography, concluding with the crushing statement: "I've had enough of being a teacher, a director ... I'm unhappy here. The only thing I want is to paint pictures ... Neither Imperial Russia nor Soviet Russia needs me." In May 1922, having created most of his greatest works, Chagall left his homeland, never to return. It would provide inspiration for the rest of his life, but from now on he had to rely solely on his memories.

For a while, Chagall settled in Berlin. It was only then that he realised how famous he had become in German art circles. Celebrated as a great Russian artist and leader of the younger generation, his paintings were considered to have ushered in Expressionism. In the previous eight years, Walden had successfully promoted

his work in several exhibitions. Chagall's paintings had entered important private collections, with Walden's wife Nell acquiring some of the best (pages 46/7) and they fetched good prices. Various publications, among them the 1921 German translation of Efros and Tugendhold's monograph and a biography by Karl With in 1923, further cemented his status. Yet despite his fame, Chagall was still in dire financial straits. Due to hyperinflation, his share of the sales proceeds was now worthless, and Walden refused to pay compensation. Chagall was devastated to have lost a huge chunk of his mature oeuvre and furious about Walden's betrayal. He struggled to settle down to work and did not paint for fifteen months. He turned to printmaking instead, quickly mastering the new medium, and illustrated his autobiography. Yet, despite slowly finding his feet, Chagall was still longing for Paris. He gladly accepted an invitation by the art dealer Ambroise Vollard to illustrate Gogol's 1842 novel *Dead Souls* and, in August 1923, returned to the French capital.

Looking back in old age, Chagall called the 1920s in France the happiest time of his life. It was a period of relative tranquillity and stability, marked by increasing national and international fame and fewer financial worries, with a regular income provided by Vollard and sales at prestigious venues. In Paris, Chagall became part of the Russian émigré circle and was happy to play the fashionable exotic outsider to his artist friends. His power of invention, expressed in works such as *The Rooster* (page 33), was keenly admired by the Surrealists who repeatedly urged Chagall to join them. Yet, suspicious of the movement's reliance on the unconscious as a prime source of inspiration and intent on retaining his artistic independence, he declined their offers.

Upon arriving in France, his art experienced another dramatic shift, away from the narrative complexity and hard-edged expressive means of the Russian years. Finding new subject matter in serene landscapes, idyllic family scenes, flowers and lovers, which he depicted in a smoother, lighter and freer style, Chagall turned into a French painter. He also honed his skills as a graphic artist. The etchings for *Dead Souls* found favour with Vollard who followed up with commissions to illustrate La Fontaine's *Fables* and the Bible, which Chagall tackled over the coming years (pages 84/5 and 86/7).

In contrast to the previous decade, the 1930s were a restless, troubled period for Chagall although his career was progressing smoothly, with well-received exhibitions in Amsterdam, Basel and London, purchases by the American collector Solomon Guggenheim and the bestowal of the prestigious Carnegie Prize. The greater financial security allowed him to go on extended travels abroad. Yet the increasing discrimination, disenfranchisement and persecution of Jews in Germany deeply worried Chagall. Having witnessed an antisemitic incident on his trip to Poland in 1935, the acute danger to Jews made him ever more conscious of his own Jewish origins. It increased his feeling of loyalty and led to questions of identity and belonging. As world events overshadowed his life, they also affected

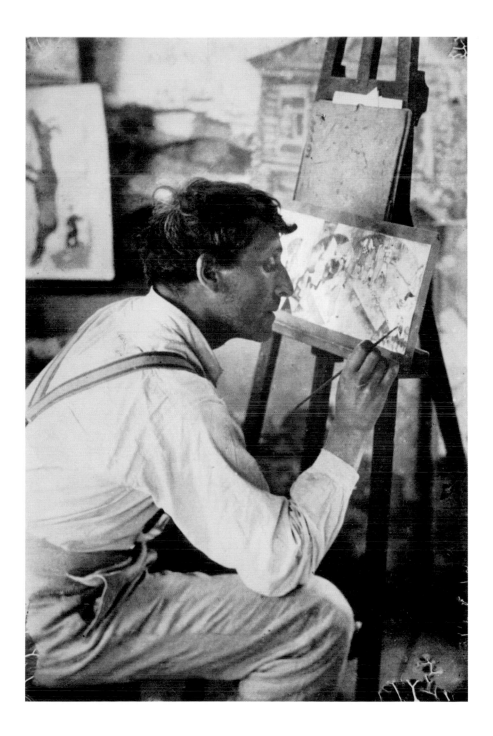

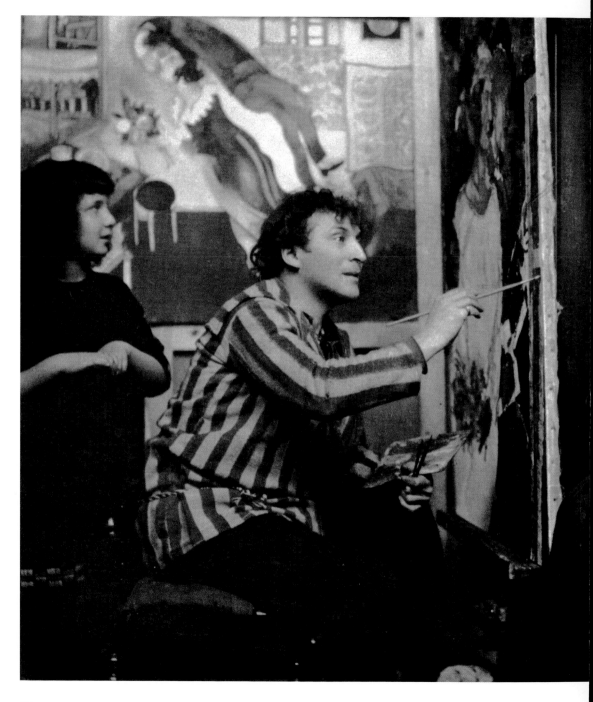

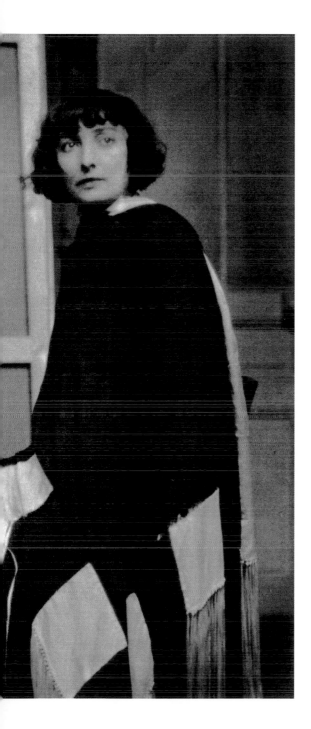

Ida, Chagall and Bella in the Paris studio, 1925

his work. It became gloomier in mood, darker in colour, increasingly monumental in size and carried strong political messages.

Not long after the National Socialists seized power in January 1933, a controversy about which art appropriately represented the new Germany began. It came to a head in 1937 when artworks not conforming to the regime's artistic ideals were classified as "degenerate", removed from public display and confiscated from museums. A representative selection of modern art that was no longer tolerated was presented to the public in the infamous exhibition Entartete Kunst (Degenerate Art). Opening in Munich in July 1937 and subsequently travelling around the German Reich attracting huge crowds, it particularly singled out abstract works or those carried out in the Cubist or Expressionist styles. Many leading contemporary artists were denounced and forced to flee the country. As a Jew who depicted the despised world of Eastern Jewry in a style officially abhorred, Chagall was the perfect example of a "degenerate" artist. Sixty-three of his works were confiscated from public collections. Two watercolours and two paintings, among them *The Pinch of Snuff* (pages 76/7), featured prominently in the Munich exhibition and more works were added to the display at later venues.

While in Germany his works suffered derision and destruction, Chagall was out of reach for the National Socialists for now. His overpowering sense of foreboding, however, found expression in paintings like *White Crucifixion* (pages 92/3). In May 1940, when German forces invaded France, he was living in Gordes, near Avignon. Although the area, as part of Vichy France, was not occupied by the Germans, the danger to Jews was steadily growing. Chagall, reluctant to leave, only made up his mind after being arrested in April 1941. Helped by the Emergency Rescue Committee and financially supported by Guggenheim, he and Bella secured a passage to New York, where they arrived in June.

Surviving in exile in the United States was difficult for Chagall. Although relieved to have escaped from Europe alive, he quickly realised that he had left behind his recognition as an artist. His style appeared too old-fashioned to an American public that favoured home-grown avant-garde trends that would eventually lead to Abstract Expressionism. Not willing to adapt and unable to speak English, he avoided the company of other artists and found no inspiration in his new, alien surroundings. Instead he expressed a yearning for his far-away Russian home and his shock at the fate of the Jews in dark, brooding works.

Chagall's luck changed in 1942 when he was commissioned by the Ballet Theatre of New York to design the set and costumes for the ballet *Aleko* (pages 96/7). He threw himself into creating monumental, vividly coloured backdrops that were enthusiastically received and gave him an appetite to work on a large scale for the rest of his life. His rediscovery of colour would also determine the remainder of his oeuvre. His standing as an artist was confirmed by the inclusion of his work in the New York group exhibition Artists in Exile (page 34), which gave an overview of the work

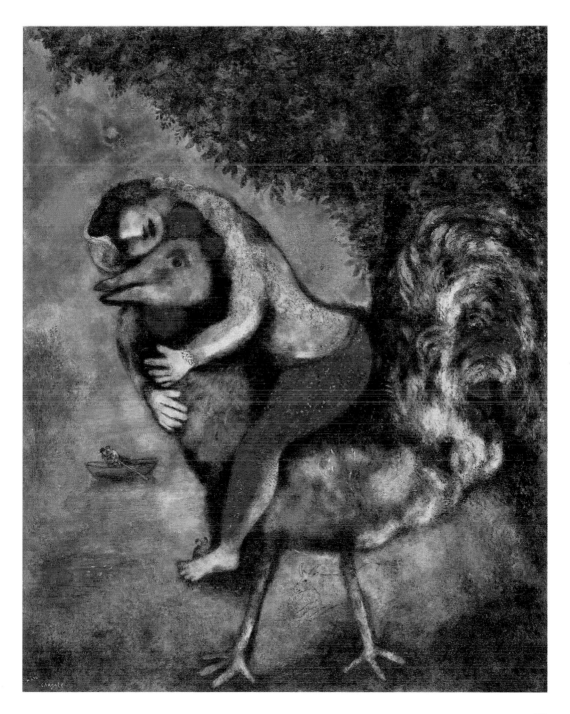

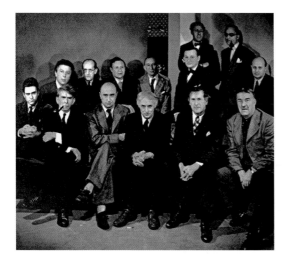

Chagall (seated, second from right) with fellow participants of the Artists in Exile exhibition at the Pierre Matisse Gallery in New York, 1942

muse and inspiration, but also his one remaining personal connection to Russia.

Shortly after the end of the war, a celebrated solo exhibition at the Museum of Modern Art in New York marked Chagall's growing recognition in the New World. He continued, however, to yearn for France. A major retrospective of his work in Paris in 1947 gave him the opportunity to re-familiarise himself with what he still considered to be the capital of art. Returning to France for good in summer 1948, he would enjoy steadily growing fame and fortune from now on. The Paris exhibition was only the beginning of a series of important and highly-regarded exhibitions throughout the world, which, in the coming decades, introduced Chagall to new audiences and turned him into an internationally recognised, celebrated and honoured artist. In the post-war period, Chagall, a Jewish survivor of National Socialism who had returned from exile, quickly acquired heroic status. His artworks, which portray loss and suffering yet also embody hope and forgiveness, captured the spirit of the time. Besides, Chagall was soon well-connected in the contemporary art scene, having rekindled old friendships and forged powerful new relationships, for example with André Malraux, the French Minister of Culture, and the Parisian dealer Aimé Maeght. His move to Vence at the French Riviera in 1950 made him a neighbour of Matisse and Picasso. Driven by mutual respect for each other's creativity, Chagall developed competitive friendships, at times marked by artistic jealousy, with both.

of European modern artists who had escaped the National Socialists and found safety in the United States. Among the participants were Jacques Lipchitz, Ossip Zadkine and Fernand Léger, old acquaintances from La Ruche, and Surrealist colleagues such as André Breton and Max Ernst, who still thought of Chagall as one of their own. The course of the war in Europe also raised his spirits, but the optimism sparked by the liberation of Paris in August 1944 was brutally shattered by Bella's death from an infection a few days later. Chagall, overwhelmed by grief, was unable to pick up a brush for several months. He had not only lost his

Chagall's private life also entered calmer waters in 1952, after a strained relationship with the young Virginia Haggard McNeil, his companion for seven years and the mother of their son David, ended. The cultured, middle-aged, Russian-Jewish émigré Valentina Brodsky, known as Vava, became his new housekeeper and, after a few months, his wife (right). Although no muse like Bella, she was the perfect companion for his later years and provided the stability he needed to concentrate on his art again. This allowed him to go back to projects left incomplete, such as the Bible illustrations, finally published in 1956. His paintings, such as the joyous *The Dance* (as illustrated on the front cover), taking up old themes and inspired by the brilliant Mediterranean light, now glowed with lush, bright colours. But over the coming decades most of his energy would be spent on exploring new artistic media. He experimented with colour lithography, sculpture, ceramics, tapestries, murals and stained glass windows, embracing the challenge of mastering the new skills and revelling in the creative freedom involved.

Since they gave him the opportunity to paint with coloured sunlight on a grand scale, stained glass windows became a particular favourite. He fastidiously learned every aspect of the craft but did away with the convention that the lead which provides structural support should also determine the confines of the image itself. This gave him greater freedom to carry out his design across large areas. One of the first commissions came from the Hadassah Medical Centre in Jerusalem, for whose synagogue he created twelve stained

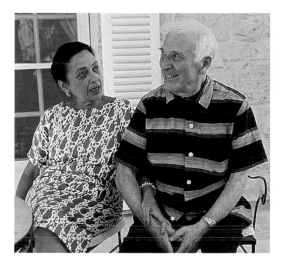

Vava and Marc Chagall, Saint-Paul de Vence, 1967

glass windows. Completed in 1962, they show the twelve tribes of Israel which, in compliance with the prohibition of the depiction of human figures, are represented by animals. Although commissions from Christian places of worship caused Chagall to wonder if he, as a Jew, should and could make a contribution, he created celebrated stained glass windows at Metz Cathedral, Fraumünster church in Zürich, Rheims Cathedral and Chichester Cathedral. In the late 1970s, he reluctantly agreed to design choir windows for St. Stephan's church in Mainz. He still refused to visit the country of the perpetrators of the Holocaust but, in the

spirit of reconciliation, seized the opportunity to emphasise the common elements of the Jewish and Christian faiths by depicting Old Testament figures.

It could be argued that, in his later years, Chagall's work lost its creative edge and simply presented repetitive and nostalgic rearrangements of a well-established repertoire of motifs, originally conceived in his heyday before 1922. While formal stylistic inventions, with some smaller exceptions like the innovative use of stained glass, certainly were a thing of the past, Chagall broke new ground with his imaginative, unconventional use of intense colour. He also kept an open mind for new subject matter, finding ideas, for example, in Greek mythology. The story of Icarus (opposite) finally provided him with a comprehensible reason for depicting a figure flying through the air. Chagall pictures Icarus falling onto an Eastern European shtetl, thus ingeniously incorporating the never-ceasing inspiration derived from his Jewish background.

In 1966, Chagall moved to Saint-Paul de Vence and set about securing the future for his large and varied oeuvre. By now, many of his works had found homes in museums and private collections all over the world. He intended to cement his legacy with a new museum dedicated to his life-long engagement with the Bible, through which he wished to convey a universal message intelligible to every creed. While the French state paid for the building, Chagall donated the artworks and the Musée National Message Biblique Marc Chagall in Nice was inaugurated in 1973.

Chagall kept working into a grand old age, concentrating on graphic work as he got frailer. By the time of his death on 28 March 1985, he had become a living monument, an acknowledged "national institution" in France, especially when, after the deaths of Matisse and Picasso, he was the last survivor of the giants of the avant garde. In Israel, he was celebrated as a national hero and praised as the greatest living Jewish painter. In Germany, his art was seen as a symbol of reconciliation and carried on gaining in popularity. In the Soviet Union, where his international fame had been ignored for a long time, the process of rehabilitation and recognition that had begun in 1973 with a flying visit to the Tretyakov Gallery in Moscow was gathering pace. More generally, Chagall's art had started to enter the popular consciousness of a mass audience. Helped by the 1964 Broadway musical *Fiddler on the Roof*, whose imagery harked back to works like *The Dead Man* and *The Fiddler* (pages 52/3), Chagall's paintings defined the image of the lost world of Eastern European Jewry to a post-World-War-II audience. Together with his more light-hearted, life-affirming depictions of love, hope and *joie de vivre*, they continue to strike a chord with viewers throughout the world, ensuring the continuing popularity of their creator and highlighting his crucial importance in the history of twentieth-century modern art.

The Fall of Icarus, 1974

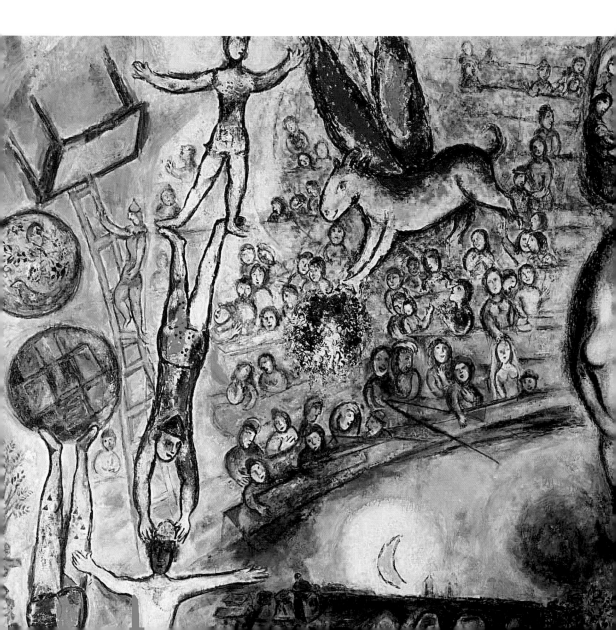

WORKS

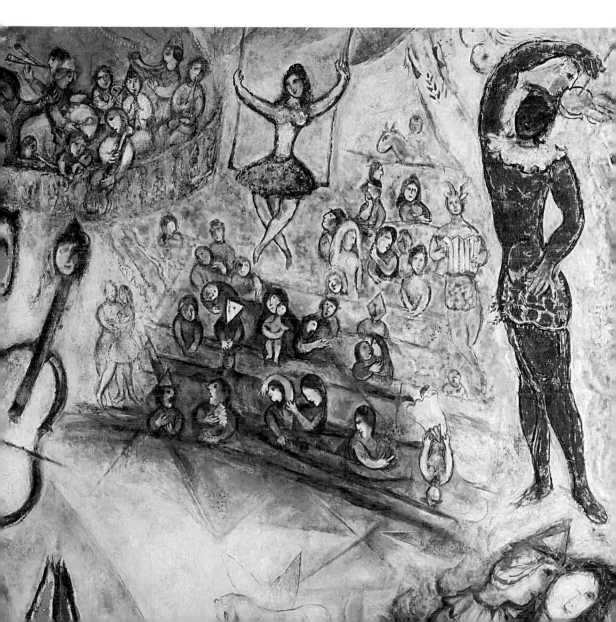

The Dead Man, 1908

Oil on canvas
69 × 87 cm
Musée National d'Art Moderne, Centre Georges Pompidou, Paris, dation 1988

Chagall considered this painting his first mature work. Having just returned to
Vitebsk from St. Petersburg, where he had been exposed to the great masters
of the past as well as examples of modern art, he now saw the once familiar sur-
roundings with fresh eyes and was ready to depict them in a new style.
Chagall shows a gloomy street of small wooden houses in which a dramatic scene
plays out. Surrounded by six candles, a dead man is laid out on the street. A woman,
probably his wife, runs away in grief and horror, arms thrown up in the air, crying for
help. Escaping between the houses, the legs of another figure can be glimpsed. In
contrast, the road sweeper, an embodiment of the grim reaper, continues his work
undisturbed and a fiddler sits on the roof, calmly playing his music.
This stark composition closely resembles a childhood memory Chagall recounted
in his autobiography. Besides, the recent death of one of his sisters might have
been on his mind when he was pondering the view of a deserted street. Wondering
how he could recreate the sense of despair and looming tragedy on canvas by
naturalistic means, he came up with the striking colour contrast, deliberately
awkward style, over-life-sized figures and shortened perspective that resemble
a stage set. Adding to the dramatic impact, the painting adroitly visualises the
Yiddish expression for "empty street" which in its literal translation means "dead
street". It also captures the customary taking of refuge on the rooftop in times of
excitement or danger, or simply to find peace as Chagall would have witnessed his
grandfather do. The boot displayed on a pole above the street alludes to one of
Chagall's uncles who is said to have played the violin like a cobbler.
Many elements of Chagall's typical style are already present in this early work: its
setting in a small Jewish-Russian town, distorted and oddly placed figures and a
sense of the magic, irrational and absurd, lifting reality to a spiritual level. Bright
colours and modern formal stylistic devices would soon be added.

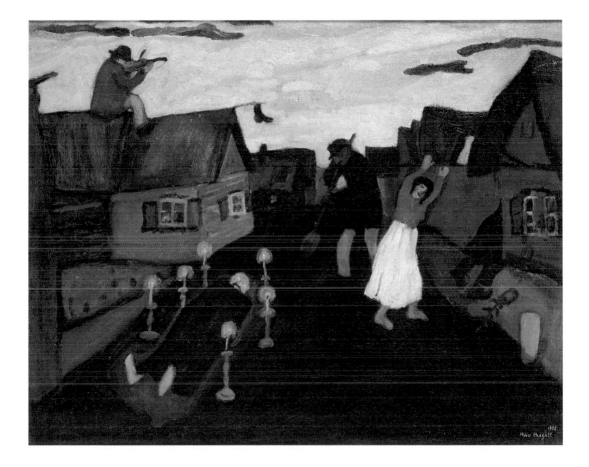

Self-Portrait with Brushes, 1909

Oil on canvas
57 × 48 cm
Kunstsammlung Nordrhein-Westfalen, Düsseldorf

In 1907, Chagall arrived in St. Petersburg a shy and unworldly art student, eager to acquire new skills and to create his own mode of expression from all the art now available to him in the city's museums. His visits to the Hermitage were particularly influential, as were his first encounters with examples of contemporary art from the West, still rare in Russia. By 1909, confident to be on the right path, Chagall was ready to present himself to the world as an artist.

In *Self-Portrait with Brushes*, Chagall takes up the tradition of seventeenth-century Dutch portraiture and in particular of Rembrandt, whose art he had studied at the Hermitage in many outstanding examples. Grasping his brushes, Chagall assumes a customary stance that announces his sophistication and accomplishments as an artist. The limited colour scheme relies on the contrast between the black gown and white collar, thereby highlighting his finely chiselled face. The faint smile echoes the self-assurance Chagall had encountered in self-portraits by Paul Gauguin yet might also express his joy at the pretence of dressing up.

All his life, contrary to truth, Chagall would attempt to portray himself as a self-taught, intuitive genius and insist on his artistic independence that owed nothing to external influences and did not pay tribute to formalism. Keeping himself separate from fellow artists, he refused to be subsumed by any movement, repeatedly declining invitations from the Surrealists. He also rejected being labelled a "Jewish artist", perceiving his art to be universal and speaking to all of humanity. However, there is one artistic influence Chagall proudly admitted to: Rembrandt. In 1922, about to leave his homeland for good, he concluded his autobiography with the following bitter remarks: "The only thing I want is to paint pictures ... Neither Imperial Russia nor Soviet Russia needs me. I am a mystery, a stranger, to them. I'm certain Rembrandt loves me."

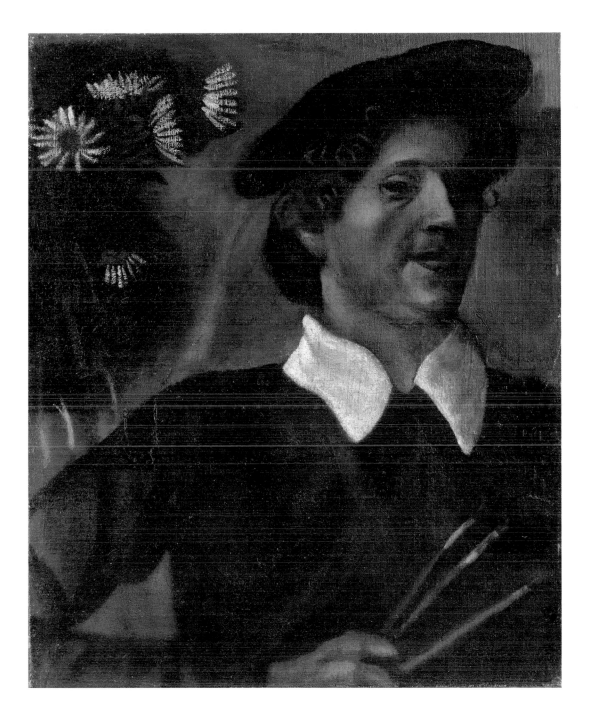

I and the Village, 1912

Gouache, pencil and watercolour on paper
61.8 × 48.9 cm
Musées Royaux des Beaux-Arts, Brussels

Chagall first created a painted version of *I and the Village* in 1911, followed by this slightly simplified variation a year later. The title was suggested by Chagall's friend, the poet Blaise Cendrars. It emphasises the close ties with his Jewish-Russian roots that Chagall, probably suffering from homesickness, captured on canvas not long after arriving in Paris. The picture conjures up a simpler life that is partly imagined and partly based on memories, recalling his hometown Vitebsk and summers spent with relatives in the village of Lyozno during his childhood. Chagall expresses his vision in the avant-garde pictorial language of French Modernism which he was encountering during his stay in Paris. He adapts stylistic elements from Cubism and Orphism to create a work of art that is truly original. The composition is centred around a young man, seen in green profile, who stares at the large head of a white cow across the foreground. In the background, a peasant carrying a scythe, and his companion, floating upside down, cross a square in a fantastical village, complete with houses turned on their roofs and a disembodied face peering out of the entrance of an onion-domed church.
In this image, Chagall visualises the connection between nature and human life that, in the Hasidic tradition, was especially celebrated. The intense eye contact of the central figures points to the partnership and interdependence between animal and man. The vignette of a woman milking a cow renders this relationship concrete.
I and the Village was particularly important to Chagall. In 1914, the original of 1911 was shown in his acclaimed solo exhibition in Berlin where it stayed while Chagall returned to Russia. Back in Paris in 1923, it was among the paintings he thought lost. Working from an illustration, he created another, smaller version in oil that, softer and less radical, is testament to the stylistic development he had undergone since 1911/12.

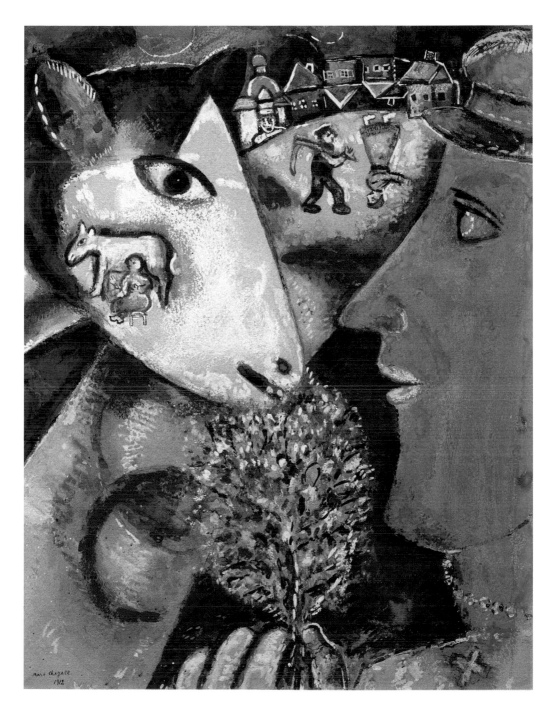

To Russia, Asses and Others, 1911

Oil on canvas
156 × 122 cm
Musée National d'Art Moderne, Centre Georges Pompidou, Paris

This painting, originally referred to as *The Aunt in the Sky*, also received its title
from Blaise Cendrars. When first exhibited at the Salon des Indépendants in Paris
in March 1912 to great acclaim, it highlighted Chagall's newly-won status as one
of the most creative exponents of modern art in Paris. It proved that Chagall, who
never wanted to paint like any other painter, was well on the way to finding his
new, distinct style.

Employing the vivid colours found in Fauvist paintings and formal devices developed
by Cubism, Chagall transforms an everyday scene from his life in Russia, the milking
of a cow, into a mysterious nocturnal fantasy. In this radical composition, he intro-
duces key motifs that would become best-remembered and most representative of
his work: gravity-defying figures floating in space and anthropomorphic animals. The
detached head of the milkmaid has its origin in Chagall's need to fill an otherwise
empty area of the canvas and serves no narrative purpose. In *Self-Portrait with Seven
Fingers*, his first self-portrait in Paris, Chagall depicts himself at work on the painting,
albeit in a simplified version, thus singling it out as the work that stands for his
emergence as a European artist.

In September 1913, *To Russia, Asses and Others* was exhibited at the Erster
Deutscher Herbstsalon in Berlin. Its organiser, the famous avant-garde art dealer
Herwarth Walden, would go on to promote Chagall, staging a large solo exhibition
the following year which marked the beginning of his fame in Germany. All the
works found buyers, with Walden's wife Nell purchasing, among others, *To Russia,
Asses and Others*. By the time Chagall returned to Berlin after the First World War
and wanted to collect his share of the sales proceeds from Walden, hyperinflation
had eaten it away. For years Chagall fought Walden, and the case was finally settled
in court in 1926. Three paintings from Nell's possession, among them *To Russia,
Asses and Others*, were returned to Chagall.

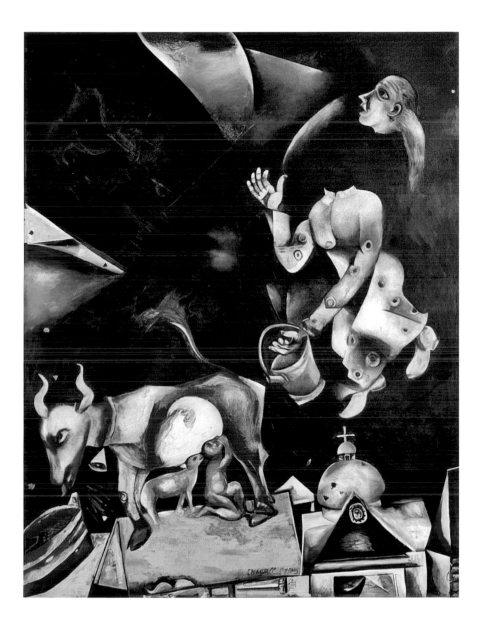

The Cattle Dealer, 1912

Oil on canvas
97 × 200.5 cm
Kunstmuseum Basel

While growing up in urban Vitebsk, visiting his parents' family in
the countryside in the summer also brought Chagall into close
contact with the Eastern European Jewish village. In Lyozno, some
fifty kilometres from Vitebsk, life was marked by poverty and the
precarious coexistence of humans and animals, which allowed both
his grandfather, a butcher, and his Uncle Neuch, a cattle dealer, to
make a living. As a child, Chagall particularly enjoyed accompanying
his uncle to market in his cart. Now struggling to adapt to life in Paris,
he expresses his longing for the world he had left behind in paintings
like *The Cattle Dealer* which combines artistic influences from the
East and the West. The depiction of the unborn foal visible in the
mare's stomach is a half-mocking reference to the image of the Child
displayed on the Madonna's chest in Russian icons (page 12). The
treatment of form, however, shows the influence of Cubism and the
choice of primary colours owes a debt to Orphism.
Chagall presents an everyday rural scene, cattle being driven to
market, in an energetic, frieze-like composition. The group is led
by the pregnant horse which, urged on by a crack of the whip,
steadfastly pulls the cart loaded with a cow. A peasant woman
carrying an animal on her shoulders brings up the rear. While the
movement of the procession is decidedly forward-bound, the dealer
and his companion are looking back over their shoulders. With this
incongruity and the unstoppably turning pair of wheels, Chagall
visualises the cyclical aspect of rural existence, determined by
ever-repeated work as dictated by nature. Mankind and animals are
linked in mutual dependence, and yet while animals are subservient
and ultimately lose their life according to man's wishes, man cannot
escape his fate either.
The Cattle Dealer was shown at Chagall's first solo exhibition in Berlin
in 1914 where it made a big impact on the German Expressionists.
Back in Paris after the war, working from an illustration, Chagall made
a copy of the painting which he displayed prominently at home for
the rest of his life.

Golgotha, 1912

Oil on canvas
174.6 × 192.4 cm
Museum of Modern Art, New York

Chagall's interest in Christian imagery dates back to his time as an art student in St. Petersburg. In 1910, having studied how the subject was treated by the Old Masters and in Russian icons, he painted a still conventional version of *The Holy Family*. *Golgotha* is Chagall's first depiction of a Crucifixion, this pivotal subject of the Christian tradition that would fascinate him for the rest of his life.

In a deliberate break with tradition, Chagall takes a radical, fresh approach with *Golgotha*. He employs the bright colours and formal stylistic elements of the avant garde he was discovering in Paris. His Christ, composed of blue Cubist segments, is a chubby, childlike figure. Against the backdrop of green discs, a compositional device characteristic of Orphism, his cross has become almost invisible and he appears to be suspended in the air. At his feet, St. John and Mary, clad in oriental dress and based on Chagall's parents, lament his death. Further back, a boat is ready to cross the river to the realm of the dead, infused with unearthly light, while a man, who has been interpreted as Judas, carries away a ladder.

Throughout his life, Chagall, both as a struggling avant-garde and later defamed "degenerate" artist and persecuted Jew, identified with Christ. Following the Jewish tradition, he understood him to be a human martyr, rather than the divine being of the Christian faith. *Golgotha* can therefore be regarded as an allusion to the fate of the Jewish people and a comment on the status of the artist in contemporary society.

Golgotha played an instrumental role in establishing Chagall's name in Germany. Then known as *Dedicated to Christ*, it was among the three paintings he exhibited to enormous success at the Erster Deutscher Herbstsalon in Berlin in 1913. Purchased by the industrialist Bernhard Koehler, a patron of the Expressionist group Der Blaue Reiter (The Blue Rider), *Golgotha* was the first major work by Chagall to be sold outside Russia.

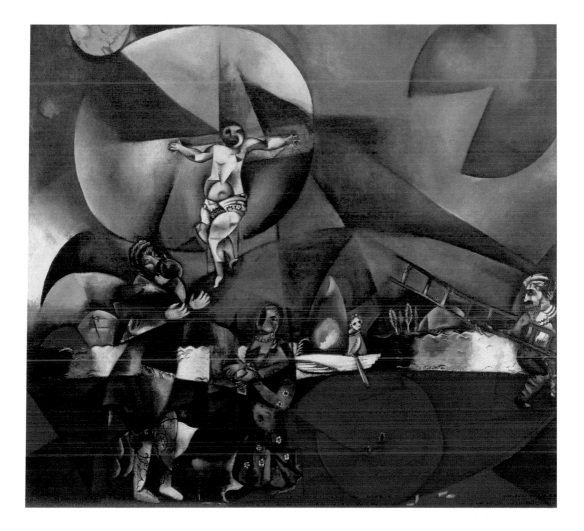

The Fiddler, 1912/13

Oil on canvas
188 × 158 cm
Stedelijk Museum, Amsterdam

The Fiddler is probably one of the best-known and most typical of Chagall's works. It brings together the traditional Jewish and Russian elements of his upbringing which he depicts in the new pictorial language provided by French Modernism. According to the Hasidic tradition, communion with God can be achieved through music and dance. A crucial presence in ceremonies and celebrations, the fiddler was therefore a constant companion throughout Chagall's early life. He loved the plaintive sound of the easily portable instrument and, following the example of relatives, who would on occasion climb up on the roof to fiddle in peace, he learnt to play it early on.

When Chagall was leaving for Paris in 1911, his future wife Bella presented him with a chequered damask tablecloth as a parting gift. Although benefitting from a small grant, Chagall, in an effort to economise, tried to use inexpensive painting materials and thus turned Bella's gift into the canvas for *The Fiddler*. Its tassels cut off, it dictated the size of the large image. Its pattern became part of the composition, showing through in places of light colour, serving as a grid for the houses and determining the chequered area by the fiddler's shoulders.

Foregoing traditional perspectives, Chagall places the life-sized musician in a snow-covered village landscape of wooden huts and church towers. His right foot, tapping the rhythm, is planted on the roof of a building while his left rests on a hill. A flying angel blesses the scene, while footprints in the snow hint at recent human activity. The fiddler's green face possibly indicates inebriation yet might also be a reference to ancient Egyptian culture where that colour was used to suggest resurrection. Taking up the figure seated on the roof in *The Dead Man*, *The Fiddler*, down-to-earth and humorous yet also spiritual and serious, celebrates the power of music— a theme Chagall would revisit many times throughout his career.

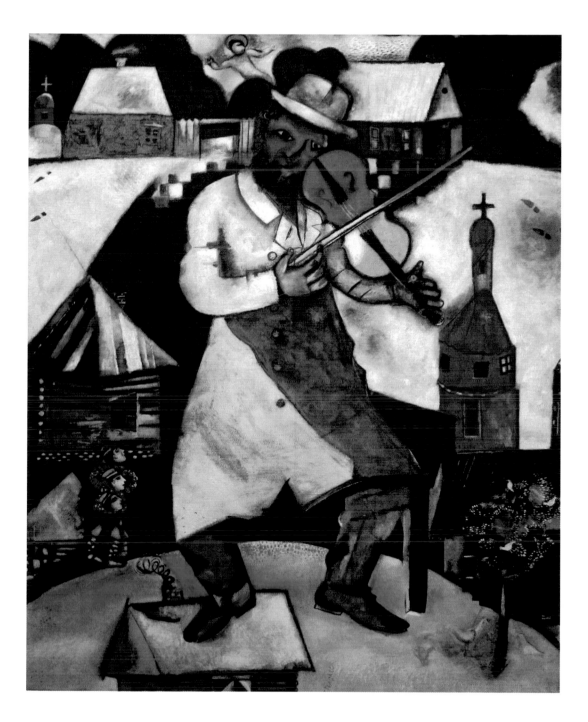

Self-Portrait with Seven Fingers, 1913

Oil on canvas
126 × 107 cm
Stedelijk Museum, Amsterdam

Self-Portrait with Seven Fingers was the first self-portrait Chagall painted in Paris.
It is testament to both the young artist's growing confidence and his struggle
with multiple identities. Employing the fragmentation and broken picture planes
of Cubism, he shows himself as a painter, palette and brushes in hand, at work
on a painting that unmistakably is his own—*To Russia, Asses and Others*. In com-
parison to the original 1911 version, the Cubist elements are now toned down,
leaving the Russian theme more pronounced.
The background pays tribute to Chagall's divided allegiances. It represents the
two artistic spheres, East and West, that he wanted to merge. Behind the easel,
a far-away, old-fashioned Vitebsk, depicted in the clouds, continues to dominate
his imagination. The artist's actual surroundings can be glimpsed through the
window on the left: modern Paris, represented by the Eiffel Tower. Robert
Delaunay's radically fractured depiction of the famous landmark, which Chagall
had encountered shortly after his arrival in the French capital in spring 1911, had
made him aware of the possibilities of Cubism and led to his own experiments
in the new style. The tiny parachutist probably refers to the tragic fate of Franz
Reichelt, a Parisian tailor and inventor, who had jumped to his death from the
Eiffel Tower in early 1912, in a failed attempt to test a wearable parachute he had
designed.
In an allusion to his threefold identity—a Jewish, Russian and European artist—
Hebrew letters above his head spell out "Russia" and "Paris". Memories of his
hometown, which he now depicts with the avant-garde techniques learnt in Paris,
would always fill his mind. The seven fingers, included as a fantastic element in
the composition, are inspired by a Yiddish saying. Doing something with seven
fingers means doing it especially well, putting every possible effort into it—the
attitude with which Chagall approached his painting.

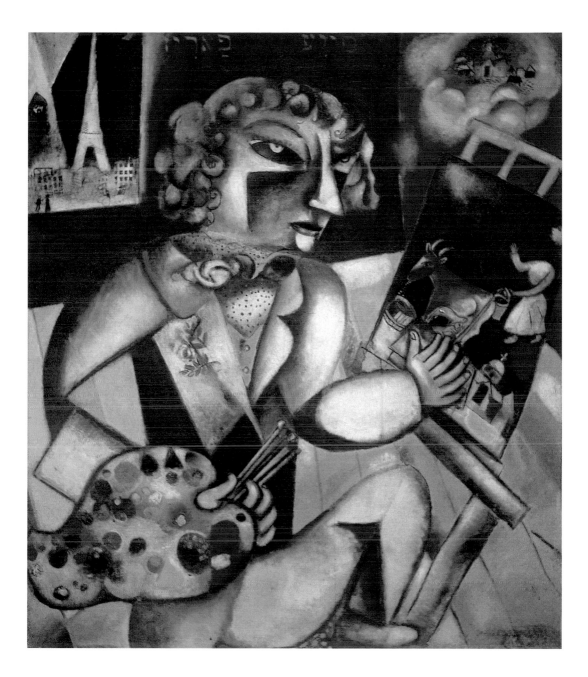

The Praying Jew or Rabbi of Vitebsk, 1914

Oil on canvas
100 × 81 cm
Kunstmuseum Basel

Following his return in 1914, Chagall saw his hometown with fresh eyes and found the Hasidic traditions of the community he had known vanishing fast. Besides, due to the outbreak of war, Vitebsk was now brimming with refugees, among them many Jews from the Pale of Settlement, retreating east to escape the fighting. This further highlighted the danger to Jewish life which Chagall began to document. He put its representatives on canvas in order "to keep them safe", as he explained in his autobiography.
In his depictions of Jews from Vitebsk, Chagall records archetypal members of society, such as rabbis, beggars and pedlars. As symbols of a world soon to disappear, he bestows them with a monumental presence. In his autobiography, Chagall described how this haunting, solemn portrait was painted from life, using a beggar as model:

"Another old man passes our house. ...
He comes in and stands discreetly by the door. He stands there for a long time. And if no-one gives him anything, he leaves without a word, as he came.
'Listen,' I tell him, '... Have a rest. I'll give you twenty kopecks.
Just put on my father's prayer clothes and sit down.'
Have you seen my portrait of the old man praying? That's him."

In comparison to the radically avant-garde works Chagall had created in Paris, *The Praying Jew* is executed in a simpler, more traditional style that incorporates extenuated Cubist elements while paying homage to Rembrandt. Taking his cue from the prayer shawl, Chagall restricted his palette mostly to black and white.
The Praying Jew was one of Chagall's favourite paintings. In 1915, it was among the twenty-five works he showed in the exhibition The Year 1915, an overview of contemporary Russian art held in Moscow. His participation was a great success and marked the start of his acknowledgement in Russia. *The Praying Jew* was particularly praised by critics and purchased by the collector Kagan-Shabshay for inclusion in the museum of Jewish art he was planning. Chagall subsequently made two copies of the painting that stay true to the original.

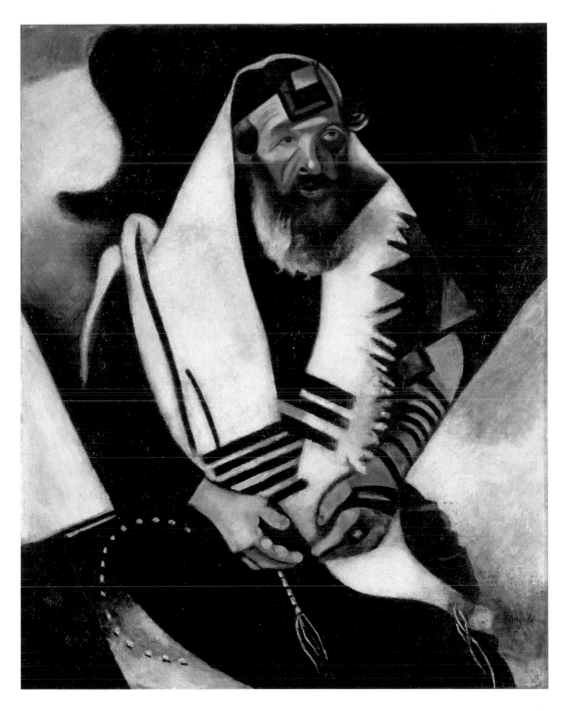

Over Vitebsk, c. 1914

Oil on card mounted on canvas
70.3 × 91 cm
Art Gallery of Ontario, Toronto

This painting, of which several later versions exist, shows the view of wintry Vitebsk that Chagall saw from the window of the room he rented not far from his parents' house. Muddy tracks left by wheels in the heavily snow-covered crossroads testify to carts having gone past recently. Yet the usually bustling neighbourhood near the railway station on the outskirts of the town now lies empty, apart from an unexpected, fantastical figure: a shabby, bearded old man with a walking stick, carrying a heavy sack on his back. More than life-size, he floats over the rooftops next to the imposing structure of the Ilyinskaya Church. His mysterious presence transforms the naturalistically rendered world beyond Chagall's window into a dreamlike, mythical place. By carefully aligning the walking stick with the leaning lamppost, however, Chagall implies a close spiritual connection between the realm of the imagination and observed reality. This is in line with the Hasidic belief in the coexistence of Old Testament stories with contemporary daily life.

The figure suggests the Prophet Elijah, who, in the guise of a sickly, stooped beggar might visit any house during the celebration of Passover to claim the place that is set for him in expectation of his redemptive arrival. The figure might also represent the legendary Wandering Jew, passing through, yet never able to settle down. On another level of interpretation, Chagall might be illustrating the Yiddish expression "er geyt iber di hayzer" (he walks over the houses), referring to a beggar moving from door to door, or depicting a "luftmensh", a resourceful man who miraculously survives by living on or in the air. Lastly, Chagall might have based his figure on Russian folk prints, a popular source of inspiration for artists, such as the late nineteenth-century example showing two surprised witnesses to a man's emergence from a chimney (page 15).

The Wandering Jew, eternally displaced, would later become a central motif in Chagall's paintings where he symbolises the National Socialist persecution of Jews.

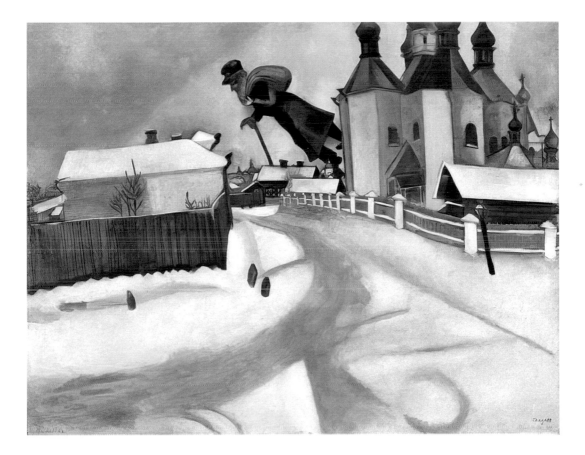

The Birthday, 1915

Oil on canvas
80.5 × 99.5 cm
Museum of Modern Art, New York

Chagall began work on this double portrait on 7 July 1915, his twenty-eighth birthday, completing it over the coming weeks in anticipation of his marriage to Bella Rosenfeld on 25 July. For a long time their relationship had seemed doomed, hampered by the long-term physical separation and objections of her parents to their liaison. Chagall had first met Bella in 1909. More secularised than her parents, well-educated, intellectual and emancipated, she was a gifted writer who wanted to become an actress, and she instilled more confidence in Chagall. They were engaged in September 1910, but a scholarship to study in Moscow soon took her away from Vitebsk. In 1911, Chagall left for Paris, only to return in summer 1914, to finally marry Bella. The outbreak of the war, however, ruined his plan to take her back to France. After initially feeling trapped, he rejoiced in their rekindled relationship.

This painting was inspired by the visit Bella paid Chagall on his birthday. Wearing an elegant dress, her hair fashionably cut, she comes bearing gifts of flowers and food. Her presence in his simple room, which is decorated with the embroidered shawls she had given to him earlier, has an unexpected consequence: Chagall is swept off his feet. Elated, he is lifted up into the air, his body elongated and energetically bent, his head turned to plant a kiss on Bella's lips. In response, she delicately floats up to meet him, evoking in the viewer an image of complete harmony.

All her life, Bella would exert a crucial influence on Chagall's work. She inspired and featured in many paintings and, in 1915, instigated a marked change in his style, away from the riotous Paris works, towards compositions of lyrical gentleness. In *The Birthday*, Chagall pays an iconic tribute to the couple's love for each other. Unforgettable in its romantic exoticism, the intimate scene captures their joy of finally being together and their hope for a happy future.

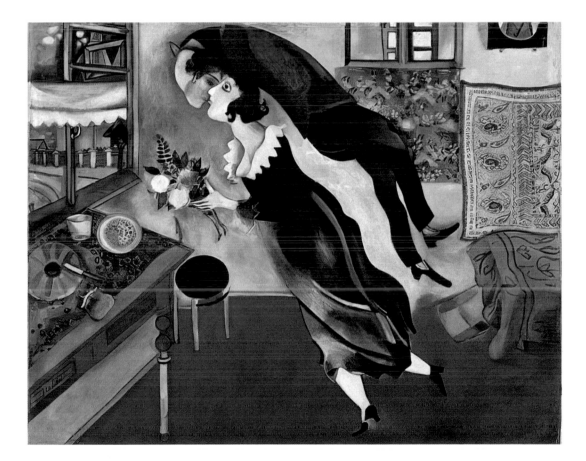

The Poet Reclining, 1915

Oil on millboard
77 × 77.5 cm
Tate Gallery, London

Chagall started work on this peaceful painting soon after his marriage to Bella Rosenfeld. It is a poetic rendering of their honeymoon, spent at the Rosenfelds' dacha not far from Vitebsk. In his autobiography, he recalled this time when they were "Alone together in the country at last" and described the surroundings: "Woods, pine trees, solitude. The moon behind the forest. The pig in the sty, the horse outside the window, in the fields. The sky lilac."

Chagall depicts himself resting in front of the house, stretched out in the field and surrounded by the peacefully grazing animals in residence. During these relaxing days Bella became pregnant, while Chagall benefitted from an unexpected source of nourishment: "It was not only a honeymoon, but also a milk-moon. A herd of cows belonging to the army was pastured not far from us. Every morning, the soldiers sold bucketfuls of milk for a few kopecks. My wife, who had been brought up chiefly on cakes, made me drink it all. So that by the autumn, I could hardly button my coats."

Despite the idyllic setting, an air of mystery surrounds the strangely isolated figure. Originally the painting had included a companion, reclining alongside and presumably representing Bella. The threatening presence of fighting armies nearby—more poignantly captured by a defenceless, lone figure—might have been a reason for this change of mind. Besides, the alteration allowed Chagall to shift the emphasis away from the sensual to a more abstract level that helps explain the enigmatic title. In pre-war Paris, he had found several friends in avant-garde literary circles that included the famous poet Guillaume Apollinaire, and among whom he became known as the "painter-poet". This soubriquet referred to his writing of well-received poems, as well as the fact that his pictures, for which he often found inspiration in literature, could be read as poems. By the time he created *The Poet Reclining*, writing was never far from Chagall's mind as he had just started work on his autobiography.

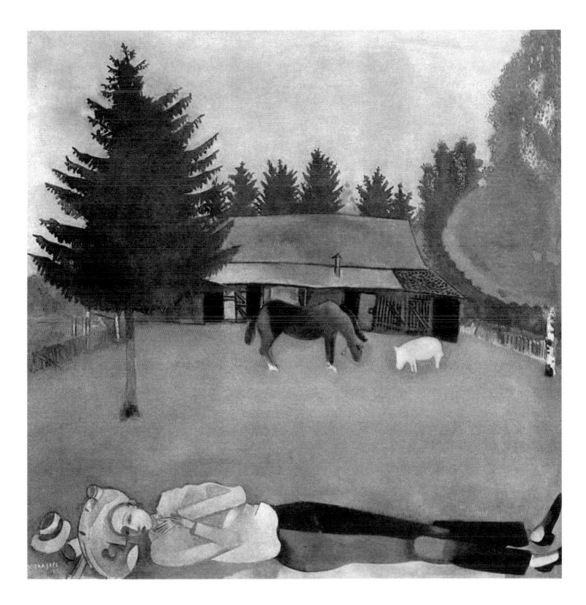

The Blue House, 1917

Oil on canvas
66 × 97 cm
Musée d'Art Moderne, Liège

In summer 1917, in the wake of the February Revolution that plunged Petrograd into violence and hunger, Chagall took his family to Vitebsk for a holiday. Nervous and worried about the future, he worked in Pen's studio, but was happiest when painting outdoors. He created a series of town landscapes that take delight in the depiction of wide-open spaces and experiment with Suprematist pictorial language.

The Blue House presents a view of Vitebsk that imitates a conventional cityscape. On the left, the grand stone houses and Baroque churches of the town centre rise majestically above the Dvina. Depicted accurately, if at times slightly lopsidedly, they give way to the embankment, the river and its adjacent meadows that are dominated by geometric elements and lead to a rickety log hut, teetering on the brink of the steep slope. Although realistic in appearance, the hut is composed solely of abstract forms. The roof consists of an irregular pattern of diverse blue shapes, broken only by the naturalistically rendered chimney pot. The logs making up the walls are depicted as horizontal lines, pierced by crooked windows, and end in neat stacks of circular shapes marking the corners of the building.

Suprematism had hit the Russian avant-garde art scene in 1915 when Kazimir Malevich showed his radical abstract painting *Black Square* in an exhibition in Petrograd. By putting an end to the idea that art had to represent reality, Malevich intended to usher in a new era. Chagall never warmed to the movement's revolutionary concept but was willing to incorporate Suprematist ideas in his steadfastly figurative work, albeit often in a playful and subversive manner. He thus arrived at a compromise that made Malevich's cold utopias intelligible. In *The Blue House*, Chagall integrates the wooden hut constructed of geometric shapes in the landscape as a matter of course, and further injects a human element by allowing a glimpse of its inhabitant through the open front door.

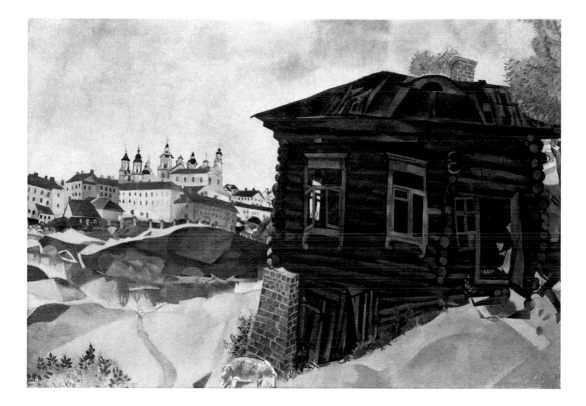

Promenade, 1917

Oil on cardboard
170 × 183.5 cm
The State Russian Museum, St. Petersburg

In November 1917, Chagall left Revolution-torn Petrograd with his family for good and returned to the relative peace and quiet of Vitebsk, where he painted monumental works that capture his joy at being home, his hope for a bright future following the Revolution and his love for Bella.

Promenade, a particularly jubilant celebration of their happiness, brings together many of the artistic influences Chagall had absorbed during the last decade. It shows the couple against the familiar view of Vitebsk, depicted in bright green under a pale grey sky. It is a backdrop that, in its reliance on geometric shapes and fragmentation, owes a debt to Cubism and Suprematism. Chagall, laughing with delight, stands firmly in a meadow. His left arm, thrown up in the air, tightly holds on to the ecstatic Bella floating above him. The Futurist manner in which the folds of her skirt are depicted enhances the illusion of movement, making Bella resemble a flag fluttering gaily in the wind. In comparison to Chagall's earlier gravity-defying figures that first appeared on canvas during his time in Paris and might have in-spired Apollinaire's comment, "Surnaturel!", the flying Bella in *Promenade* appears relatively naturalistic. She is at peace with her unusual state that is caused by her lightness of being, due to her blissful union with Chagall. The small bird in his right hand alludes to a play by one of Bella's favourite writers, Maurice Maeterlinck's *The Blue Bird*, whose main characters discover that true happiness is to be found in small things and the love offered at home.

Promenade is one of the very few paintings Chagall signed in Cyrillic, as if in proud affirmation of his Russianness. Indeed, during the three years following its creation, Chagall enjoyed the highest level of fame in his native country. Prominently dis-played at the first official overview of Russian avant-garde art in Petrograd in 1919, *Promenade* was subsequently purchased by the state.

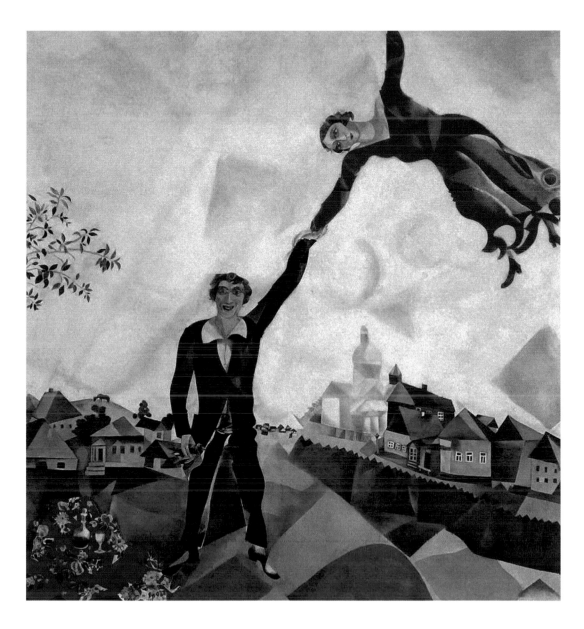

The Apparition (Self-Portrait with Muse), 1917/18

Oil on canvas
157 × 140 cm
Private collection

A passage in his autobiography describes where Chagall found inspiration for this unusual and striking painting:

"And dreams oppressed me: A square, empty room. In one corner, a single bed, and me on it. It is getting dark.
Suddenly, the ceiling opens and a winged being descends with a crash, filling the room with movement and clouds.
A rustle of trailing wings.
I think: An angel! I cannot open my eyes, it's too light, too bright.
After rummaging about all over the place, he rises and passes through the opening in the ceiling, taking all the light and the blue air away with him.
Once again it is dark. I wake up.
My picture 'The Apparition' evokes this dream."

In his rendering of the surprise visit, Chagall shines a light on his current dilemma. As a Jew and a member of the working class he was harbouring high hopes of the Russian Revolution. What the promised freedom meant for the future of art, however, still had to be decided. In *The Apparition* (*Self-Portrait with Muse*), Chagall imaginatively depicts the moment the artist is called upon to play his part in this epic struggle and proposes a solution: the amalgamation of the old and the new.
He demonstrates his awareness of the artistic canon by taking up the centuries-old theme of the Annunciation. Yet, by placing himself at work at an easel, in the place of Mary, and depicting the angel's visit from the right instead of the conventional left, he subverts the tradition. He further breaks the established mould by employing unfamiliar avant-garde pictorial language: the nocturnal scene plays out in a cramped artist's studio defined by four triangles. While the angel forcefully delivers his message, the artist tentatively raises a brush to the canvas to start on his task. Sure enough, the appointment as Commissar of Arts for Vitebsk in autumn 1918 placed Chagall in the unique position of actually determining the future role of the arts in post-Revolutionary Russia.

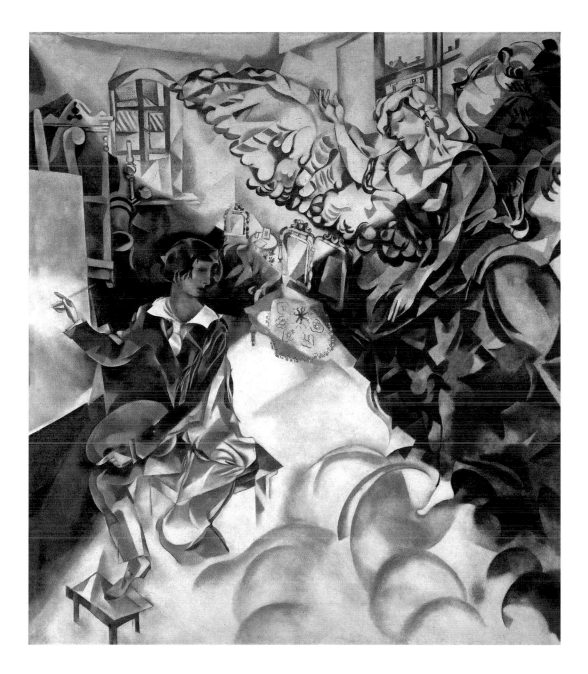

Profile at the Window, 1918

Gouache and ink on card
22.2 × 17 cm
Musée National d'Art Moderne, Centre Georges Pompidou, Paris, dation 1988

In the years following the Revolution, the nature of art that best represented the new regime was a hotly discussed issue. Initially, various competing strands were accepted, as demonstrated by the first state exhibition of home-grown avant-garde art, held in Petrograd in 1919, where both Chagall's figurative compositions and Kazimir Malevich's abstract Suprematist creations featured prominently. Although Chagall was suspicious of art used for political ends and could not relate to Malevich's total break with tradition, he was willing to experiment with Suprematism, eventually incorporating some of its elements in his works.

Profile at the Window is probably the most extreme example of Chagall's attempt to come to terms with Suprematism. With three thick white lines he conjures up a Suprematist grid. However, by adding a figurative element, the profile of a man with a black cap, he makes it human and turns the abstract signs into a story: now a man is leaning out of a window and shouting to someone down in the street.

As Commissar of Arts for Vitebsk, Chagall experienced the ideological battle for the politically correct Soviet art at first hand. The followers of his representational style at the art school he had established were soon lured away by the charismatic Malevich, forcing Chagall to leave both the school, and a few years later, the country.

For a while it seemed as if Suprematism, Russia's very own radical and nihilistic avant-garde movement, would play a major role in building a Soviet society. Yet, by the 1930s it became clear that both Chagall and Malevich had lost. Soviet art had to appeal to the uneducated masses, and avant-garde art, deemed too difficult to understand, was repressed. It was replaced by a conservative, representational Socialist Realism that easily transported political messages. All the while, Chagall bravely defied the regime, painting in his unassimilated figurative manner for which he experienced decades of ostracism in his homeland.

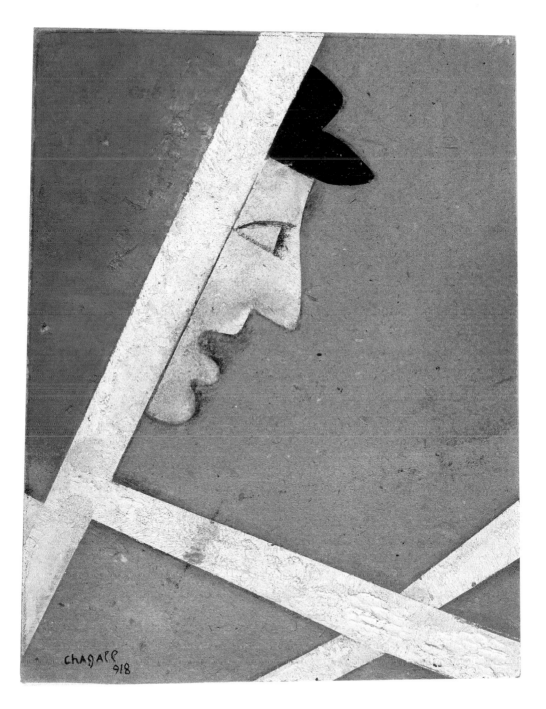

Sketch for Introduction to the Jewish Theatre, 1920

Watercolour, ink, gouache and chalk on paper
17.3 × 49 cm
Musée National d'Art Moderne, Centre Georges Pompidou, Paris, dation 1988

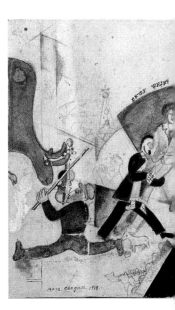

In November 1920, Chagall was commissioned to create the stage design for the Jewish Theatre in Moscow which, following the Revolution, was thriving. Situated in a nationalised apartment, the theatre boasted a small auditorium which Chagall decorated with murals. The seven large paintings are among the most ambitious and exciting works in his entire oeuvre. Viewed together, they can be taken as a summary of his artistic aspirations: the definitive illustration of Russian Jewry, at a precarious time in his career. In a perfect fit to the Jewish Theatre's non-naturalistic, often grotesque presentation of shtetl life, Chagall presents traditional Jewish themes in a style that draws on Yiddish folk art, as well as the vocabulary of modern art.

Chagall turned the auditorium into a homogeneous "total work of art" that soon acquired the nickname "Chagall's box". One wall was taken up by the monumental *Introduction to the Jewish Theatre*. The energetic tableau of life-sized figures is difficult to decipher. It is depicted here in the preparatory sketch which Chagall was photographed working on (page 29). On the left, the critic Abraham Efros, co-author of the first monograph on Chagall, introduces the artist, palette in hand, to Alexander Granovsky, the company's artistic director. His troupe of actors, musicians, dancers and acrobats stretches out behind in a long procession. Many of Chagall's favourite motifs are scattered around the composition. The village scenes and freely roaming animals are reminders of Vitebsk, while a man riding a cockerel and another eating a shoe provide a tragicomic, surreal touch. In the lower right-hand corner, a vignette showing Chagall, Bella and their daughter Ida takes the place of a signature. Looking back, Chagall considered the murals for the Jewish Theatre to be the greatest work he had ever produced. When the theatre was closed, the murals entered the collection of the Tretyakov Gallery, where they were kept in storage. In 1973, he was finally allowed to see them again and proudly remarked "I was a good artist, wasn't I?", adding his signature. The murals were subsequently restored and put on permanent display in the 1990s.

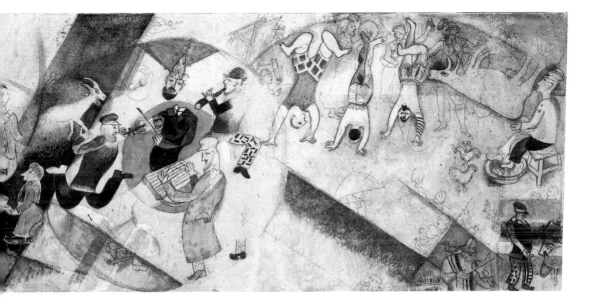

Self-Portrait from the portfolio Mein Leben, 1922/3

Etching and drypoint
27.6 × 21.7 cm
Museum of Modern Art, New York

In 1915, Chagall, then in his late twenties, began to compile his autobiography.
By 1922, as he was about to leave Russia for good, it was complete. Written in an
idiosyncratic style, the lively memories of his early life are only partially based on
reality and constitute a work of art in their own right.

In Berlin, Chagall embarked on an illustrated edition of his memoirs, commissioned
by the gallery owner and publisher Paul Cassirer. He chose a graphic technique,
etching, that was not popular at the time, but had a long tradition in Germany.
Chagall quickly mastered the unfamiliar medium and learnt to use it innovatively.
The German translation of the Russian original, however, proved to be too
complicated and thus twenty etchings were published without the text in a
portfolio entitled *Mein Leben* (My Life) in 1923.

Often using motifs from earlier paintings, Chagall portrayed members of his family
and important events from his past in touching vignettes. He employed needles
of varying sizes, frequently in combination with drypoint, and left large parts of
the composition empty to achieve a range of effects that mark him out as a highly
original, modern graphic artist.

Self-Portrait, a frank self-assessment, is in fact a group portrait, showing the
sources of his inspiration. It acknowledges his past in Vitebsk, as exemplified by his
parents propping up his head, which, in turn, is crowned by a wooden house, his
childhood home. In the small figures of Bella and Ida and the vast empty space, he
looks to the future with its endless creative possibilities.

The entire text of the autobiography was published in the New York-based Yiddish
journal *Di Tsukunft* in 1925. In 1931, its French version, *Ma Vie*, came out, translated
and censored by Bella. The publication of the portfolio in 1923 was a decisive
moment in Chagall's life. It led to several commissions for book illustrations by the
Parisian dealer Ambroise Vollard which enabled him to earn a living for his family
for the foreseeable future.

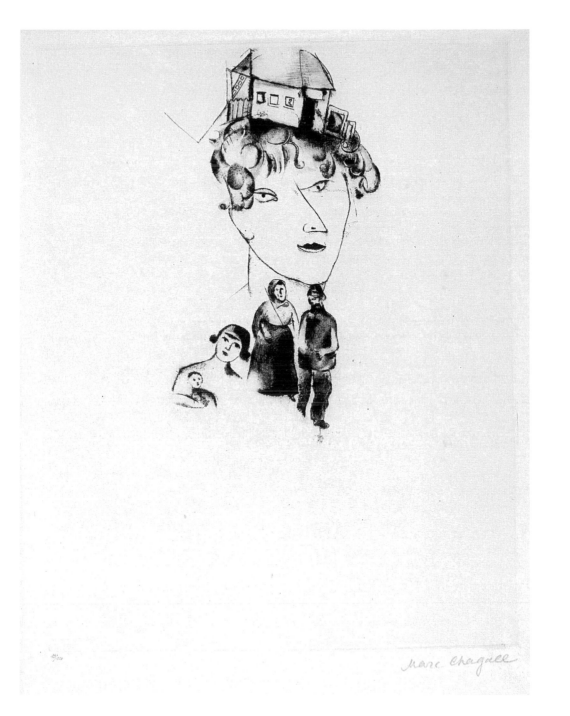

The Pinch of Snuff, 1923

Oil on canvas
117 × 89.5 cm
Kunstmuseum Basel

Chagall models this iconic portrait, which is based on an earlier version from 1912, on traditional depictions of Jewish dignitaries, such as those his teacher Yehuda Pen would have painted. Yet he infuses it with a deliberately primitivist, unreal air. At first glance it simply depicts a proudly erect, wide-eyed, old rabbi indulging in a pinch of snuff on the Sabbath, when the prohibition of lighting a match makes smoking impossible. It has also been suggested, however, that Chagall here alludes to a wondrous story by the Yiddish writer I. L. Peretz, whose protagonist succumbs to the same temptation and thus, in Peretz's view, breaks the rules of the Sabbath. The painting might therefore carry the consoling message that even figures of authority show human weakness and sin.

The fate of this painting illustrates a heinous chapter in the story of art in the twentieth century. Purchased by the Städtische Kunsthalle Mannheim in 1928, it early on became the focus of the National Socialist campaign against modern art. In April 1933, it was shown in an exhibition deriding "Images of Cultural Bolshevism" at the Kunsthalle. Local mockery turned into national denunciation when, in July 1937, the painting was confiscated from the Kunsthalle and included in the exhibition Entartete Kunst (Degenerate Art) in Munich. Renamed *Rabbi*, it was the perfect embodiment of what the National Socialists hated about modern art: a Jewish creator, an Eastern Jewish subject, an Expressionist style and non-naturalistic colours. The painting stayed in the exhibition when it toured to Berlin, Leipzig, Düsseldorf and Salzburg in 1938, and then became part of the Third Reich's attempt to turn "degenerate" art into foreign currency on the international art market. On 30 June 1939, the Galerie Fischer in Lucerne held an auction of 125 paintings and sculptures confiscated from German public collections, including three works by Chagall. *Rabbi* was bought by the Kunstmuseum Basel for the modest price of 1,600 Swiss Francs.

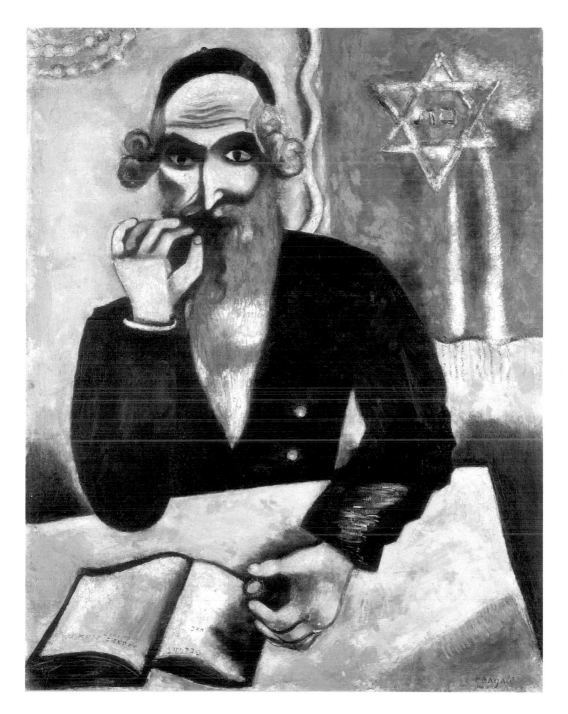

Green Violinist, 1923/4

Oil on canvas
198 × 108.6 cm
Solomon R. Guggenheim Museum, New York

In the figure of a violinist dancing in a rural village, Chagall expressed nostalgia for his faraway homeland. The painting also reflects the difficult situation he found himself in on his return to Paris in 1923, when he discovered that almost all the works he had left in his studio at La Ruche in 1914 had disappeared. Having already lost many paintings through Herwarth Walden, all his works from the crucial pre-war period were now gone. Although an established artist, he lacked the works to prove it and quickly embarked on recreating his early oeuvre, working from photographs or memory. Often the replicas are not simple copies, but rather new versions with marked differences.

Green Violinist is based on a number of earlier versions of the same subject, starting with *The Fiddler* of 1912/13. Among the murals Chagall created for the Jewish Theatre in Moscow in 1920 was another, even closer example, *Music*, part of a quartet that also comprised *Dance*, *Theatre* and *Literature*, embodied through the Jewish characters of fiddler, marriage broker, wedding jester and Torah scholar.

Already suggesting the change of style Chagall's paintings would undergo in the 1920s, *Green Violinist* is a lighter and less intense rendering of a familiar theme. While the central character, apart from his altered attire, remains fundamentally unchanged, the background is drastically simplified. It has lost many of its details and appears bleached of colour, making the violinist's green face stand out even more prominently. The pronounced Suprematist elements apparent in *Music*, such as a black triangle tearing open the biggest cloud, are also only hinted at in *Green Violinist*.

Apart from producing replicas of works he thought lost, Chagall recreated paintings he had brought with him from Russia to feed the growing demand for his art. Never completely faithful to the original, the new versions exhibit some degree of variation in style and a mixing of well-known motifs—a method that Chagall would later use in many of his compositions.

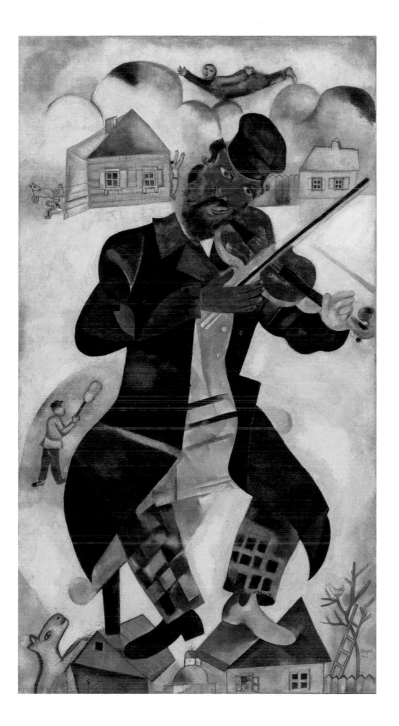

The Window at the Île de Bréhat, 1924

Oil on canvas
98 × 72 cm
Kunsthaus Zürich, Vereinigung Zürcher Kunstfreunde, Gift Gustav Zumsteg, 1970

This painting illustrates the drastic change in Chagall's art on his return to Paris in 1923. After the tumultuous, at times dangerous years in Russia, he now enjoyed a relatively carefree decade, marked by a happy private life, which allowed him to concentrate on his work. In this new-found contentment, his paintings lost their hard edge and became calmer and simpler. Turning away from complex, memory-driven compositions, Chagall found inspiration in his immediate surroundings. He created several portraits of Bella, as well as a number of enchanting, intimate family scenes featuring Bella and Ida. He also began painting landscapes, inspired by the countryside of rural France, which he explored on many long holidays during the 1920s.

The Window at the Île de Bréhat was painted in summer 1924, when the Chagalls were staying on the Île de Bréhat off the coast of Brittany. It presents the view across a promontory towards a lighthouse and the sea beyond. The idyllic scene is captured in light colours that harmoniously bring together the internal and the external spaces. Chagall created another version of this painting in which he combines two of his recently discovered subject matters. In Ida at the Window, his daughter, now 8 years old, is shown seated on the window sill, enjoying this view.

In December of the same year, Chagall had his first solo exhibition in France, held at the Galerie Barbazange-Hodebert in Paris and organised by the art dealer Pierre Matisse, son of the painter. Chagall's new, mellower style demonstrated to the outside world that he had learnt from his French contemporaries and adapted to the currently favoured, more conservative fashion. The exhibition attracted much praise, confirming Chagall as one of the country's foremost artists.

Ida grew up to be a selfless promoter of her father's career. She took on the role of his main supporter when Bella became unwell in the 1930s and for many years after the war acted as his dealer. In 1952, she married the Swiss art historian Franz Meyer who would write an authoritative monograph on Chagall.

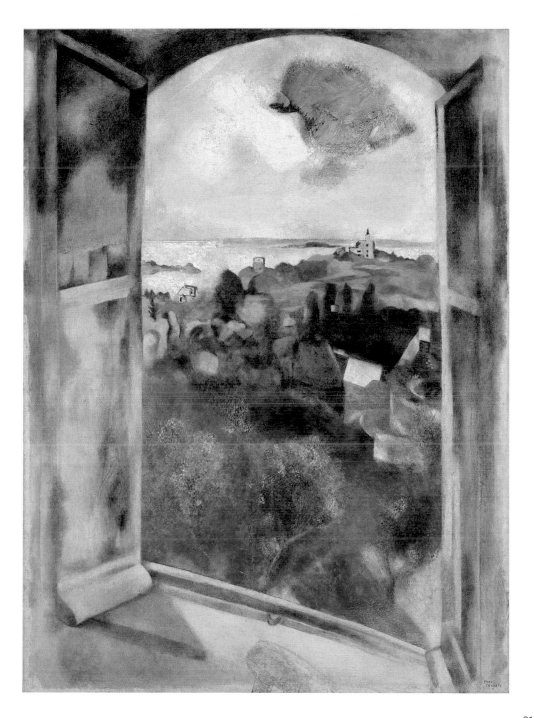

Lovers among Lilacs, 1930

Oil on canvas
131.4 × 89.5 cm
Metropolitan Museum of Art, New York

Lovers among Lilacs captures Chagall's optimism and *joie de vivre* in France
during the 1920s, which he referred to as the happiest time of his life. They are
expressed in a subject matter that would become the hallmark of his later oeuvre:
lovers with flowers.

Lovers had already occasionally featured in Chagall's paintings, as for example in
Lovers in Blue (page 23). Flowers had also entered his life with Bella, as depicted
in *The Birthday*, and would turn into symbols of their lasting mutual attraction and
attachment. In 1926, during a holiday on the Côte d'Azur, Chagall was fascinated
by a bouquet Bella had purchased at the local market. With their lush colours
glowing in the intense Mediterranean light, he discovered flowers as a main motif.
Often depicted on a monumental scale, the smoother, softer, lighter style he had
developed in France perfectly matched the subject matter that, now paired with
an embracing couple, became complete in *Lovers among Lilacs*.

In this surreal, dreamy composition, a giant bouquet of lilacs, placed amidst a
tranquil river scene, conjures up an early summer's night. A pair of young lovers,
modelled on Chagall and Bella, are nestled among the white and pink flowers
which offer protection from the outside world. The woman, whose nudity is rare
in Chagall's work, abandons herself to the tender caresses of her suitor, her bare
breasts echoing the full moon and its reflection in the water.

Although clearly autobiographical in origin, Chagall's joyous paintings of lovers
with flowers struck a chord with the public and have proved especially and
enduringly popular. Attempting to meet the demand, Chagall created many
versions of this theme in various media over the decades to come. Most of these
works were purchased by private individuals and, like *Lovers among Lilacs*, only
recently started entering public collections.

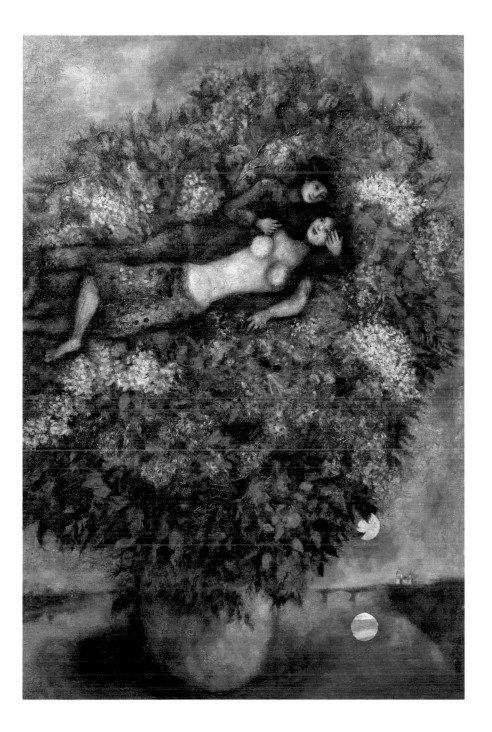

The Cat Transformed into a Woman, c. 1928–31/1937, from La Fontaine's *Fables* (1926–31)

Etching and drypoint, hand-coloured in oil
29.5 × 24 cm
Tate Gallery, London

In 1926, Ambroise Vollard commissioned Chagall to illustrate La Fontaine's *Fables*. The choice of a foreigner for this seventeenth-century French classic, based on Aesop, outraged critics, yet Vollard argued that a Russian artist, who through his background and culture best understood the magic of the oriental sources for the fables, was an ideal match.

Fables takes a close, satirical look at human nature, using animals as main characters. Having an exterior reason for depicting animals, who had been central protagonists of his paintings anyway, suited Chagall perfectly. While Bella read the fables to him, he brought them to life with an imaginative array of anthropomorphic creatures.

By October 1927, he had created a hundred colour gouaches which he intended to convert into colour etchings. The process, however, proved to be too complicated and, between 1928 and 1931, Chagall carried out the etchings in black and white, subsequently hand-colouring a few.

The Cat Transformed into a Woman exemplifies the saying "old habits die hard" with the story of a man who so loved his cat that he turned it into a woman and married her. Yet, despite appearing to be the perfect wife, she had kept some of her feline traits and continued to hunt mice. The thrill of the chase, however, was diminished as the mice did not see her as a cat and were less inclined to run away. Chagall added colour to this etching in 1937. While probably achieving an effect close to the original colour gouache, he thereby covered up much of the varied texture that was a particular feature of his *Fables* etchings.

In 1930, Vollard showed the *Fables* gouaches in Paris and Berlin. Comparing his recent work to that of the Neue Sachlichkeit (New Objectivity), the modern realist movement then fashionable in Germany, Chagall realised how firmly integrated in the French art world he was by now. Although all the gouaches found buyers, Vollard subsequently did not manage to publish Chagall's *Fables* illustrations as a book. They were finally brought out by Tériade in 1952.

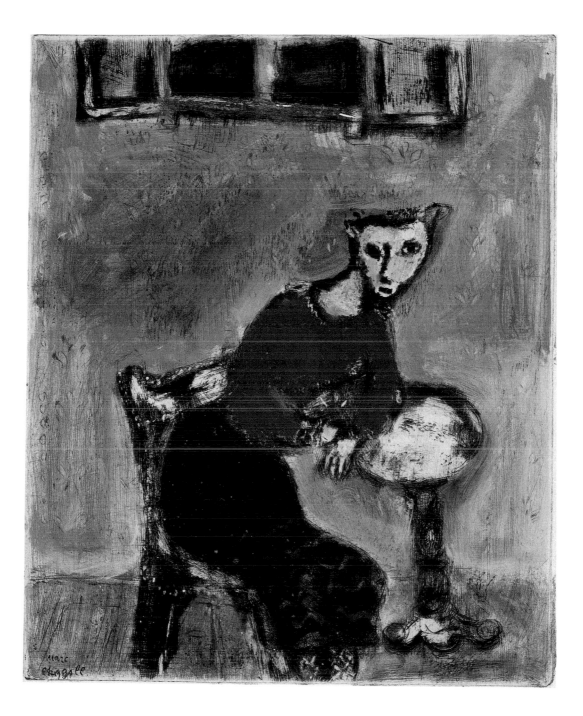

Abraham and the Three Angels, 1931

Oil and gouache
62.5 × 49 cm
Musée National Marc Chagall, Nice, donation 1966

In 1930, Chagall took up Ambroise Vollard's suggestion to illustrate the Bible. He tackled a typically Christian theme that had occupied many artists in the past, mindful that this project would enable him to explore his own Jewish roots, although he had stopped being observant as a teenager. In the tradition of his Hasidic upbringing, Chagall understood Bible stories as coexisting with the life of ordinary people. To find stimulation, compare an imagined world with reality and connect past and present, he travelled to Palestine in 1931. While the visit had little direct visual impact on the Bible illustrations, experiencing the ancient sites instilled an empathy for the country's inhabitants that he injected into his images.

In the Bible illustrations, Chagall brings together Christian and Jewish traditions in an unprecedented way. In consciously primitive images that range from the monumental to the intimate, he created an array of archetypal characters that express a range of human emotions. While some illustrations hark back to paintings by great masters such as Rembrandt and El Greco, *Abraham and the Three Angels* is based on an icon by the medieval Russian painter Andrei Rublev, housed in the Tretyakov Gallery. It shows the angels seated around a table on their visit to Abraham to announce that his wife Sarah would bear a son. Chagall subverts the familiar image by reversing the composition, turning the angels' backs to the viewer and removing their halos, thus infusing it with a casual domestic ambience.

Chagall first carried out his Bible illustrations as gouaches which he then turned into etchings. This meticulous process was interrupted in 1939 and only taken up again in 1952. By 1956, Chagall had completed the 105 etchings which then were issued by Tériade. His preoccupation with the Bible, which had inspired him since childhood, continued, resulting in a series of biblical paintings over the coming decade and giving birth to the idea for a museum devoted to the subject.

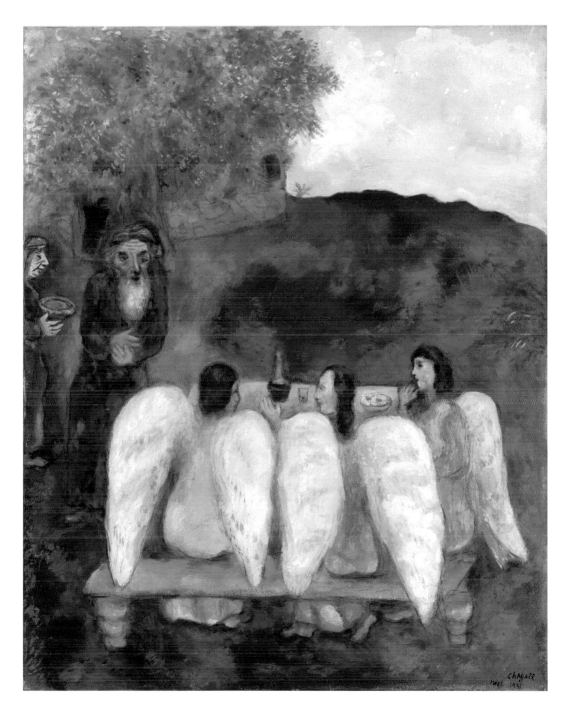

Solitude, 1933

Oil on canvas
102 × 169 cm
Tel Aviv Museum of Art

Solitude is one of Chagall's most memorable paintings, haunting in its melancholic simplicity and outspoken in its political message. Created as a response to the National Socialist seizure of power in Germany, which made Chagall more aware of his own Jewish roots than ever, its brooding seriousness and dark colours evoke the uncertain and dangerous future Jews were now facing.

Solitude refers back to Chagall's earlier depictions of old Jews and rabbis and follows on from his Bible illustrations for which he had found inspiration on his visit to Palestine in 1931. It presents a lone Jew, pensive and forlorn, sitting in a meadow under a threatening sky. His only possession, which he tenderly holds, is a Torah scroll. Beside him, under the protection of a hovering angel, rests a white heifer with a golden violin. Firm parts of Chagall's repertoire of motifs, both assume a clear symbolic meaning here: the violin is a typically Jewish instrument and the heifer, according to the Book of Hosea, one of the books of the Hebrew Bible, represents the children of Israel—the answer to the Wandering Jew's questioning of where he belongs.

Chagall identified with this uprootedness, as the buildings of Vitebsk in the background imply, and understood the suffering it brought. Unable to return to Russia, he longed to put down permanent roots in France. Yet he was refused French citizenship until 1937 on the grounds that, as Commissar of Arts for Vitebsk, he had held an official post in Communist Russia. Emigrating to Palestine, on the other hand, was never an option for Chagall, who was not a Zionist. Although feted by Meir Dizengoff, the mayor of Tel Aviv, he had felt alien and found his art unappreciated during his recent stay there. In 1953, however, Chagall presented *Solitude* to the Tel Aviv Museum of Art as a gift. Finally, an example of his art that incorporated memories of his origins in Vitebsk found a home in Israel.

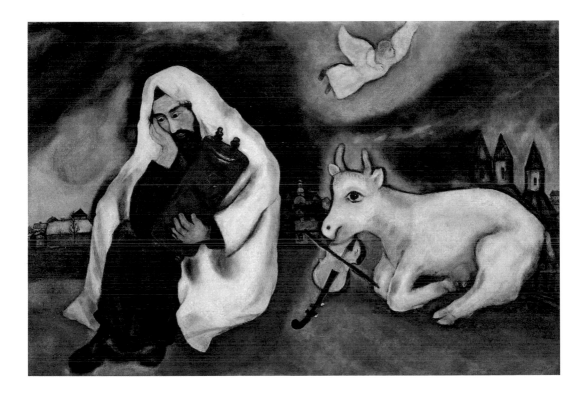

Nude over Vitebsk, 1933

Oil on canvas
87 × 113 cm
Private collection

The rise of antisemitism in Nazi Germany prompted Chagall, who followed events from the relative safety of France, to paint the "twin masterpieces, one sacred, one profane," of *Solitude* and *Nude over Vitebsk*. Both explore issues of belonging and identity, distressingly brought to the fore all of a sudden. While the former tentatively holds out the promise of a spiritual community of the Jews, the latter falls back on Chagall's personal history in an exploration of a world endangered. As the titles imply, Chagall explicitly links *Nude over Vitebsk* to his iconic depiction of a figure floating over the city in *Over Vitebsk* from around 1914, of which, in the interim years, he had created several versions.

To great effect, Chagall infuses this enigmatic picture that, in its illogical combination of elements, comes close to Surrealism with its simple drama. For once he refrains from focusing on the humble outskirts of Vitebsk, with their low wooden houses, and instead presents a view of the grand stone buildings of the town's fashionable historic centre, dominated by the Baroque Uspensky Cathedral on top of the hill. In the pale sky above the deserted cityscape floats a monumental sleeping nude, depicted from the back, for which Chagall's now 17-year-old daughter Ida had posed, resting in the shade of a tree. A rare subject in his paintings, the naked female form is skilfully rendered, testifying to his intimate knowledge of the long tradition of depicting nudes in Western art.

Yet in this sombre, almost uniformly grey composition, in which only the enormous bouquet of blood-red flowers provides a hint of colour, the nude's sensuousness is dwarfed by its vulnerability. Although still unaware of the dangers in store, the pleasures and desires she represents are in jeopardy, and the sense of premonition, doom and grief appear already all-pervading.

White Crucifixion, 1938

Oil on canvas
155 × 139.7 cm
The Art Institute of Chicago

Beginning with *Golgotha* in 1912, Chagall repeatedly addressed the theme of
Christ on the Cross during his life. In *White Crucifixion*, he employs it to record his
response to the recent atrocities against Jews in Germany that culminated in the
Reichspogromnacht (November pogrom). The powerful and complex painting
presents an apocalyptic vision of their persecution and suffering in a series of
horrific scenes of violence, flight and misery that are grouped around the central
figure of the crucified Christ. The crying patriarchs hovering at the top of the
cross helplessly look on as Jews, among them the eternal Wandering Jew carrying
a sack on his back, flee at the bottom. One clasps a Torah roll to his chest, while
another displays a label around his neck that denounces him as a Jew. It originally
read "Ich bin Jude" (I am a Jew) before Chagall overpainted it. On the left, a horde
brandishing weapons and red flags approaches a world turned upside down.
Houses are burning, their inhabitants killed or turned into refugees attempting
to escape by boat. On the right, a German soldier, whose armband had originally
displayed a swastika, desecrates and sets a synagogue aflame.
In this eclectic composition, Chagall brings together figures from the Old Testament
with contemporary people and infuses traditional Christian iconography with openly
Jewish references and political messages. Through the prayer shawl draped around
his loins and the inscriptions, proclaiming him to be "Jesus of Nazareth King of the
Jews", the figure on the cross is clearly marked out as Jewish. He therefore, on the one
hand, is no longer able to bring the Christian message of salvation and redemption.
Following the Jewish tradition, he personifies martyrdom and suffering, here symbolis-
ing the Jewish victims of Nazism. On the other hand, by reminding Christians that
Christ was a Jew, he is calling on them to stop persecuting his brothers.
Chagall would paint several further versions of the Crucifixion which, in the coming
decade, turned into despairing comments on the unfathomable inhumanity of the
Holocaust.

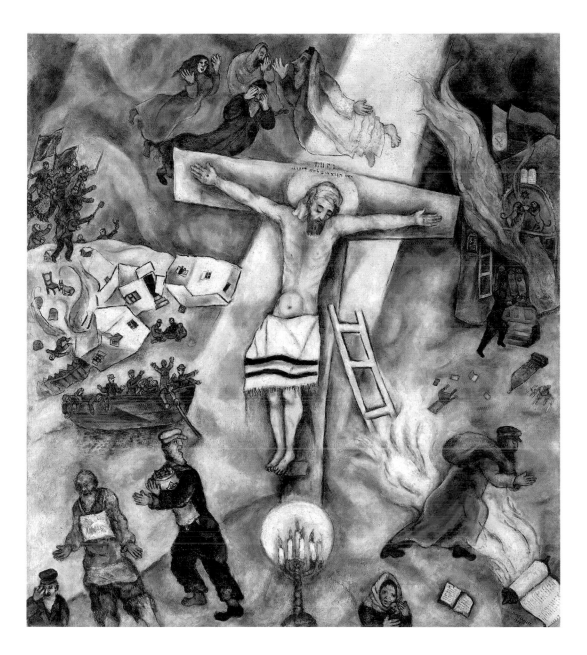

Time is a River without Banks, 1930–39

Oil on canvas
100 × 81.3 cm
Private collection

At first glance, *Time is a River without Banks* appears to be an archetypal Surrealist painting. Yet the dramatic juxtaposition of incongruous objects owes nothing to chance, but is infused with complex symbolic meaning, firmly rooted in Chagall's past and reacting to current world events.

In 1935, Chagall attended the opening of a museum of Jewish art in Vilna. The city, part of Poland since 1922, had been the hub of Yiddish life in the Pale of Settlement during his childhood. Now tensions were rising and Chagall, who witnessed an antisemitic incident, realised the threat to Jews. As a defector from Communism, he was prohibited from reaching Vitebsk, just across the Soviet border. In the poem "My Distant Home", written in Yiddish and published in 1937, Chagall gave expression to his feelings of nostalgia, longing and loss, also captured in *Time is a River without Banks*.

The painting, whose title is taken from Ovid's *Metamorphoses*, depicts a monumental pendulum clock floating above the river Dvina, calmly flowing through Vitebsk in the fading twilight. It is attached to a large, winged fish that, with the help of a hand emanating from its mouth, plays the violin. While the fish refers to Chagall's father who had hauled barrels at a herring factory, the clock represents his father-in-law, the owner of three shops selling jewellery, watches and clocks. Together they watch over the lovers, Chagall and Bella, tenderly embracing on the riverbank.

During Chagall's childhood, the grandfather clock in his parents' house had set the pace of life. Over the decades, clocks would often feature in his work, particularly in times of trouble and unhappiness. *The Clock*, painted in Vitebsk in 1914, for example, immortalises his feelings of impotence and claustrophobia at being trapped in Russia at the outbreak of war. In *Time is a River without Banks*, the clock symbolises memory and the passage of time which, moving like a river, can never be stopped.

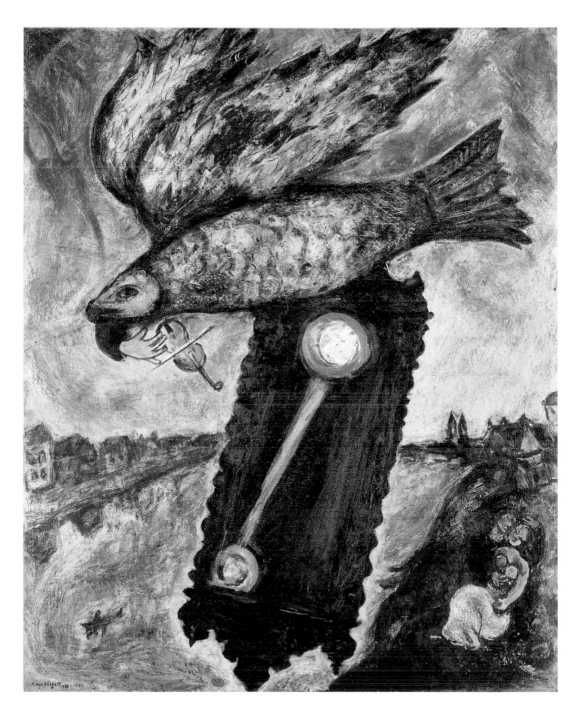

A Wheatfield on a Summer's Afternoon (set design for scene 3 of Aleko), 1942

Gouache, watercolour, wash, brush and pencil on paper
38.5 × 57 cm
Museum of Modern Art, New York

Chagall was passionate about the theatre all his life and made several designs for the stage throughout his career. In 1942, he had his first opportunity to work on a ballet when the Ballet Theatre of New York commissioned him with the set and costume designs for *Aleko*. Based on Pushkin's 1842 poem *The Gypsies* and Tchaikovsky's *Piano Trio*, the ballet tells the story of a youth who abandons his life in the city, joins a gypsy camp and falls in love with Zemphira. When he is betrayed, Aleko kills both Zemphira and her lover.

The commission came at a particularly difficult time for Chagall, who had remained an artistic outsider since he had fled France and found asylum in the United States in 1941. It helped boost his confidence by giving him a much-needed outlet for his creativity. Most of the work was carried out in Mexico City where Chagall, closely collaborating with the choreographer Léonide Massine, devised and painted a large backdrop for each of the four scenes. In a marked change from the sombre paintings of recent years, Chagall employs pure colour in bold compositions that, in their monumentality and sparseness, reflect the vast plains of the American South he encountered en route to Mexico, and could be read as paving the way to Abstract Expressionism.

In *A Wheatfield on a Summer's Afternoon*, the backdrop for scene 3, Chagall created a yellow landscape that overwhelms with its simplicity, tension and intense colour, suggesting passion and heat. On the left, a sun glares over a field of corn, ready to be harvested, while on the right, Zemphira and her lover enjoy an assignation in a boat under a huge moon. The blood-red celestial bodies and the scythe, half-hidden amidst the crop, hint at the drama to ensue.

Aleko premiered to much acclaim in Mexico City in September 1942 and transferred to the Metropolitan Opera in New York a month later. Chagall's designs were widely seen as the true star of the show. One critic pointed out that his backdrops did not make good sets but were wonderful works of art of which the dancers obstructed the view.

Entre chien et loup
(Between Darkness and Night), 1943

Oil on paper mounted on canvas
100 × 73 cm
Louvre Abu Dhabi

Although Chagall had only recently rediscovered colour through his work on the set design for *Aleko*, large parts of this painting are dark and gloomy. The sombre palette reflects his mood during exile in the United States, when worries about the fate of Europe, his career and Bella's declining health were preying on his mind. While Bella, about to complete her memoirs, was preoccupied with the past, Chagall attempted to find consolation in capturing his daydreams on canvas, combining memories of his hometown with allusions to France where he longed to be again.

A familiar street of Vitebsk, where snow-covered low wooden houses huddle in the wintry darkness, provides the background to this painting. Barely illuminated by the slim crescent of the moon, the scene includes several surreal elements, perhaps inspired by Chagall's recent re-encounter with some of Surrealism's main protagonists at the exhibition Artists in Exile: a heavily-laden sleigh flying across the roofs, an unlit lantern walking across the street and a bird-headed mother reading a book to her child. Chagall originally conceived this painting as a self-portrait, placing himself, brushes and palette in hand, in front of an easel and sporting a pair of wings. Yet he subsequently hid one wing under the snowy street and turned the other into a portrait of Bella. Cloaked in a red shawl, she emerges, ghostlike, from an open window, her deathly white profile merging with Chagall's blue face, thus creating an intimate double portrait whose three colours evoke the French flag.

The French title, which literally translates into "between a dog and a wolf" and refers to the time of dusk, captures the painting's undefined threat and sense of foreboding better than the English version. As Bella died unexpectedly in August 1944, this disembodied portrait was among the last Chagall created while she was alive. Over the coming decades he would poignantly pay homage to their event-filled life together, recreating Bella's likeness from memory.

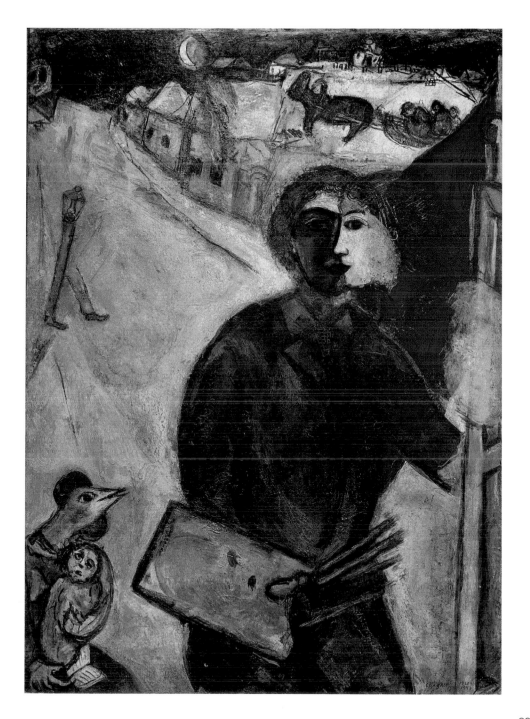

The Flayed Ox, 1947

Oil on canvas
100 × 81 cm
Musée National d'Art Moderne, Centre Georges Pompidou, Paris
Donated by Ida Chagall

This painting was created in the immediate aftermath of the Holocaust. It records Chagall's horror, as, from his exile in the United States, he followed the truth about the concentration camps and the fate of the European Jewry reported in newspapers and so unsettlingly shown in Pathé newsreels.

To capture his response to the atrocities, Chagall drew on the memories of his grandfather, the butcher. As a child, Chagall, fascinated by the cruel spectacle, had witnessed him slaughtering many cows. Taking his cue from carcasses of beef in paintings by Rembrandt and Chaim Soutine, Chagall depicts a monumental skinned animal. Cut open, its bloody flesh gleaming bright red, it swings from a pole, appearing to be lapping up its own blood from a tub. The savage scene is set amidst the wooden houses of a wintry, night-time Vitebsk. The butcher, knife in hand, hovers helplessly over the streets from which all human presence has been extinguished. He watches aghast as flames are threatening in the distance.

The flayed ox clearly represents the violated, tortured and annihilated Jewish people. In its resemblance to a crucified human body, however, it can also be read as a self-portrait, following on from Chagall's earlier identifications with Christ on the Cross that had become more pronounced in recent years. As Golgotha turns into Vitebsk, Chagall pours all his sadness about the losses of the past and his fears for the future into this powerful and violent painting.

Taken by the Germans in July 1941, Vitebsk had suffered a terrible fate in the war. The 16,000 Jews who had not managed to flee were put in a ghetto and soon faced liquidation. By the time the Soviet Army had liberated the city in June 1944 after fierce fighting, it was completely destroyed, its buildings burnt down and almost all inhabitants dead. Chagall would never return to Vitebsk, but in his art he created a lasting monument to his childhood home and the now lost world of Eastern European Jewry.

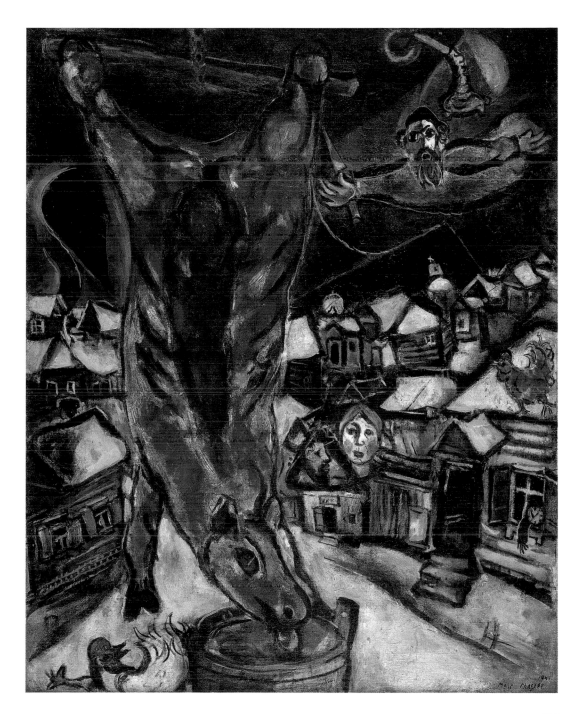

Champs de Mars, 1954/5

Oil on canvas
149.5 × 105 cm
Museum Folkwang, Essen

By the early 1950s, Chagall lived in a villa on the outskirts of Vence and relished his growing fame in France. He worked on a series of richly coloured, joyful paintings that celebrate his love of Paris, the city most formative for his art. In *Champs de Mars*, begun in the year of the tenth anniversary of Bella's death, he also commemorates the happiness he had found with his second wife Vava. From a rich, upper-middle-class, Russian-Jewish background, Vava provided a vital connection to his homeland. She also looked after and protected him from any distraction, so that he could work in peace.

In *Champs de Mars*, which takes its title from the park where the Eiffel Tower stands, Chagall brings together some of his favourite themes and motifs. A pair of lovers, Chagall and Vava, float over a town that is reminiscent of Vitebsk. The background is populated by famous Parisian sights, the basilica of Sacré-Coeur and the Eiffel Tower, silhouetted against the red sun. In homage to his first marriage, Chagall is holding out a bouquet of flowers to the small figure of Bella, cradling the infant Ida. An anthropomorphic bird sits at a table, decorated with a basket of fruit, demonstrating Chagall's mastery at filling empty space on the canvas. The dominant circles that surround the Eiffel Tower and, halo-like, protect the central couple, pay tribute to the great influence Orphism had on his art.

Champs de Mars, with its numerous personal references to the past and present, can be read as a succinct visual autobiography. Yet to appreciate the painting, it is not necessary to decipher the clues. Indeed, such an approach might not be in the artist's interest. When asked to explain the content of a similar painting, Chagall replied: "Say that I work with no express symbols but as it were subconsciously. When the picture is finished, everyone can interpret it as he wishes." This invitation to the viewer to let their imagination roam freely might explain the lasting popular appeal of paintings like *Champs de Mars*.

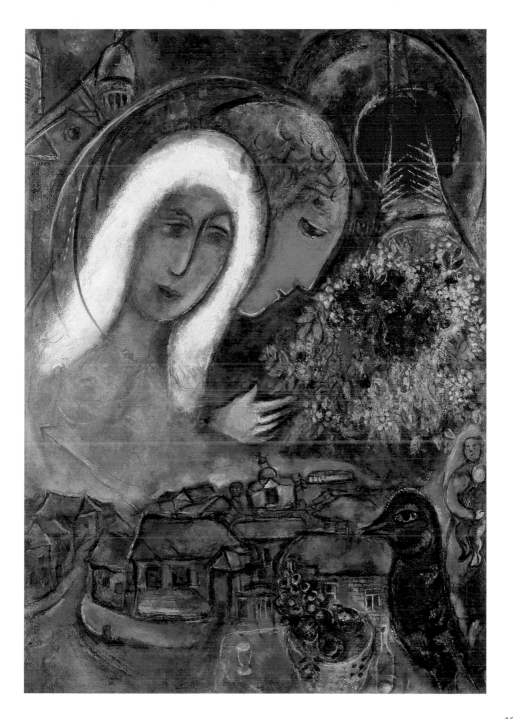

Commedia dell'Arte, 1958/9

Oil on canvas
250 × 400 cm
Foyer of the Städtische Bühnen, Frankfurt am Main
(on loan from the Adolf und Luisa Haeuser-Stiftung, Frankfurt am Main)

Throughout his life, the circus was a great source of inspiration for Chagall. Fascinated by the acrobats who had performed at village fairs in his childhood, he had occasionally included them in his early compositions, such as *Introduction to the Jewish Theatre* in 1920. In winter 1926/7, Chagall regularly joined Ambroise Vollard in his box at the Cirque d'Hiver in Paris. He was captivated by its theatrical atmosphere which conjured up an enchanted world of its own, just as he did in his paintings. And just like artists, acrobats and harlequins kept the masses entertained, yet were not fully accepted members of society. Tragicomic figures, their performance represented all aspects of life, mirroring its sorrows and joys. Following their circus visits, Vollard urged Chagall to create illustrations on the subject. Chagall made nineteen gouaches that became known as the *Cirque Vollard,* and also painted a series of circus scenes. From now on, they would be a leitmotif of his work, to which he would return frequently after the Second World War.

In 1958, Chagall was invited to create a mural for the foyer of the new opera house-cum-theatre to be built in Frankfurt am Main. Although uncomfortable with working for a German patron, Chagall was by now thinking in huge dimensions and, grateful for the opportunity to decorate a large wall, accepted the commission. Drawing on well-established motifs, *Commedia dell'Arte* presents the gaudy goings-on of a magic circus performance in a tightly-packed arena. Surrounded by an improbably balanced tower of acrobats, a winged flying horse and a contortedly fiddling harlequin, a cello-playing creature, composed of a human body and a green donkey's head, takes centre stage. A pair of lovers, originally modelled on Chagall and Bella, and a night-time view of houses by a river between which Chagall, signature-like, places his profile, refer to his private life. Installed in the completed building in 1963, *Commedia dell'Arte*, Chagall's largest painting in Germany, has since reached a particularly wide audience.

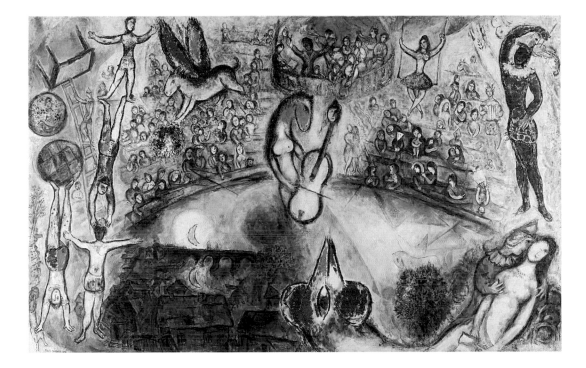

Ceiling of the Opéra Garnier, 1964

Paris

In 1963, Chagall received one of his most prestigious commissions when the French Minister of Culture, André Malraux, invited him to design a new ceiling for the Paris Opéra, housed in the nineteenth-century Palais Garnier, a famous Parisian landmark. Proud of the murals he had done for the Jewish Theatre in Moscow in 1920 and on the lookout for a chance to work on a large scale again, Chagall was thrilled to redecorate the auditorium of this neo-Baroque building.

His ceiling consists of twelve enormous canvas panels which cover an area of 240 square metres around the huge central chandelier. It pays homage to operas and ballets that deal with the theme of love by composers like Berlioz, Mozart, Mussorgsky, Tchaikovsky, Verdi and Wagner. Employing a spectacular range of luminous colours, Chagall incorporates myriad musical references in his familiar repertoire of embracing couples and flying creatures. All this is arranged among famous Parisian monuments, such as the Arc de Triomphe, the Eiffel Tower and the Palais Garnier itself. In some images, Chagall immortalises his personal history, referring, for example, to the set and costume designs he had done for the American Ballet Theatre's production of Stravinsky's *The Firebird* in 1945 or for Ravel's ballet *Daphnis and Chloe*, a commission from the Paris Opéra in 1958.

The opening of the renovated building was celebrated in September 1964 with a performance of *Daphnis and Chloe*, using Chagall's recent designs. The ceiling, for which Chagall declined remuneration, was enthusiastically received. In a repetition of the controversy surrounding his illustrations for La Fontaine's *Fables*, however, some commentators criticised that a foreign artist had been allowed to work on this French project. Still, it proved Chagall's ongoing creative brilliance and reinforced his reputation as one of the greatest European painters of the twentieth century. He was subsequently awarded the Grand Cross of the Légion d'Honneur, the highest honour bestowed by the French government.

Crucifixion, chœur, baie centrale
All Saints' Church, 1967

Tudeley, Kent, England

The small eighteenth-century parish church of All Saints' in the village of Tudeley
in Kent is the only church in the world with all its stained glass windows designed
by Chagall. It is also a rare instance of his usual range of motifs being applied to
illustrate a concrete incident that occurred in the life of a fellow human being other
than his own.

In 1963, 21-year-old Sarah d'Avigdor-Goldsmid died in a sailing accident off the coast
of Sussex. Recollecting Sarah's admiration for the stained glass windows Chagall
had created for the Hadassah Medical Centre in Jerusalem, her father, Sir Henry
d'Avigdor-Goldsmid, asked Chagall to design the east window of the church in
which she had worshipped, in her memory.

The lower half of the window shows the moment of drowning: Sarah, the fateful
sailing boat toy-like in her lap, is engulfed by swirling water. Nearby, her mourning
mother cradles her two daughters. While the surviving child is depicted brightly,
Sarah already fades away in shadowy paleness. On the right, Sarah's lifeless body,
arms outstretched, is washed up on the shore. In the upper part of the window, a
horse carries Sarah, glancing back one last time at her mother, towards a ladder that
leads straight to heaven. At its top Christ on the Cross and angels await her.

When, in 1967, Chagall saw the completed east window in situ, he was so charmed
by the surroundings that he offered to create stained glass windows for the rest
of the church. In an act of great generosity, he refused to accept any payment for
his work, as he did for other sacred sites. The installation of the eleven additional
windows was completed in 1985. Dominated by blue and yellow, they are mainly
abstract in design with occasional figures discernible. Referred to as "paintings in
light", they spectacularly transform the tiny space, infusing it with an air of spiritual
intensity. They also offer a message of consolation: in times of human tragedy, faith
is a healing force, embodied by the loving and comforting figure of Christ.

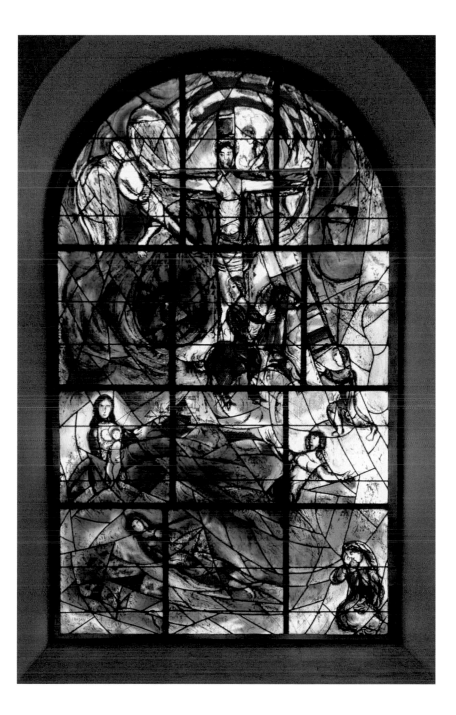

FURTHER READING

Bohm-Duchen, Monica, *Chagall*, London/New York 2001

Chagall, Marc, *My Life*, London et al. 2018

Chagall, ex.cat., Royal Academy of Arts, London 1985

Chagall: The Breakthrough Years, 1911–1919, ex.cat., Kunstmuseum Basel/Guggenheim Museum, Bilbao 2017/18

Chagall, Lissitzky, Malevich: The Russian Avant-garde in Vitebsk, 1918–1922, ex.cat., Centre Georges Pompidou, Paris/Jewish Museum, New York 2018/19

Chagall: Love and the Stage, 1914–1922, ex.cat., Royal Academy of Arts, London 1998

Chagall: Love, War, and Exile, ex.cat., Jewish Museum, New York 2013

Chagall: Modern Master, ex.cat., Kunsthaus Zürich/Tate Liverpool 2013

Compton, Susan, *Marc Chagall: My Life—My Dream. Berlin and Paris, 1922–1940*, Munich 1990

Marc Chagall and the Jewish Theater, ex.cat., Solomon R. Guggenheim Museum, New York/The Art Institute of Chicago 1992/3

Meyer, Franz, *Marc Chagall*, London 1964

Wullschlager, Jackie, *Chagall: Love and Exile*, London et al. 2008

PHOTO CREDITS